Unlikely Friendships

For Kate, Will, Elliott, and Jasper.

And for Mom, of course.

Library of Congress Cataloging-in-Publication Data is available.

ISBN 978-0-7611-5913-1

Design by Raquel Jaramillo

Photo credits: COVER: Front, CNImaging/Photoshot; back from left to right, © Rohit Vyas, © Rex USA, © Rina Deych. INTERIOR: p. iii, CNImaging/Photoshot; p. iv, p. viii, © Twycross Zoo; p. vi top left, © Ron Cohn/Gorilla Foundation/koko.org; pp. vi–vii, © Helen J. Arnold; p. vii bottom right, p. xiv © Rex USA; p. xiii, Jennifer Hayes; p. 3, p. 4, p. 5, © Rex USA; p. 6, © dpa/Landov; p. 8, © EPA/ALEXANDER RUESCHE/Landov; p. 9, © Associated Press/Fritz Reiss; p. 10, p. 13, Lisa Mathiasen and Julia Di Sieno; p. 14, © Barb Davis, Best Friends Volunteer; p. 18, p. 21, © 2011 Zoological Society of San Diego; p. 22, p. 24, © Elizabeth Ann Sosbe; p. 26, p. 29, © Johanna Kerby; p. 30, © Jennifer Hayes; p. 34, p. 37, © Barbara Smuts; p. 38, p. 41, Solentnews.co.uk; p. 42, p. 45, Melanie Stetson Freeman/© 2006 The Christian Science Monitor; p. 46, p. 48, p. 49, Laurie Maxwell/Jonathan Jenkins; p. 50, Bob Pennell/Mail Tribune; p. 54, p. 57, p. 58, p. 59, © Ron Cohn/Gorilla Foundation/koko.org; p. 60, © Rhino & Lion Nature Reserve; p. 64, p. 66, p. 67, © Rina Deych; p. 68, p. 71, © Rohit Vyas; p. 72, Miller & Maclean; p. 76, BARCROFT/FAME; p. 79, p. 80, p. 81, noahs-ark.org; p. 82, THE NATION/AFP/Getty Images; p. 86, CNImaging/Photoshot; p. 90, p. 93, p. 94, Anne Young; p. 96, p. 99, Bob Muth; p. 100, © Associated Press; p. 104, p. 107, Lion Country Safari; p. 108, p. 111, © Jeffery R. Werner/IncredibleFeatures.com; p. 112, p. 114, p. 115, ZooWorld, Panama City Beach, FL; p. 116, p. 119, Dimas Ardian/Getty Images; pp. 121–122, © Associated Press/Achmad Ibrahim; p. 122, p. 125, SWNS; p. 126, p. 129, © Rex USA; p. 130, p. 133, Dean Rutz/The Seattle Times; p. 134, p. 137 Göran Ehlmé; p. 138, p. 141. pp. 142–143, © Helen J. Arnold; p. 144, p. 147, pp. 148–149, BARCROFT/FAME; p. 150, p. 153, Lauren E. Rhodes; p. 154, p. 157, Maggie Szpot; p. 158, p. 161, © Associated Press; p. 162, p. 165, p. 167, BARCROFT/FAME; p. 168, p. 171, p. 173, BARCROFT/FAME; p. 174, p. 177, © Omer Armoza; p. 178, p. 181, Deb and Terry Burns; p. 182, Norbert Rosing/National Geographic Stock; p. 186, p. 189, Koichi Kamoshida/Getty Images; p. 190, © Associated Press; p. 194, © Rhino & Lion Nature Reserve; p. 198, © Houston Zoo; p. 202, p. 203, © Twycross Zoo; p. 204, © Jennifer Hayes.

Workman books are available at special discounts when purchased in bulk for premiums and sales promotions as well as for fund-raising or educational use. Special editions or book excerpts also can be created to specification. For details, contact the Special Sales Director at the address below, or send an e-mail to specialmarkets@workman.com.

Workman Publishing Company, Inc.
225 Varick Street
New York, NY 10014-4381
www.workman.com

Printed in the United States of America
First printing May 2011

10 9 8 7 6 5 4 3 2 1

Unlikely Friendships

47 REMARKABLE STORIES
from the ANIMAL KINGDOM

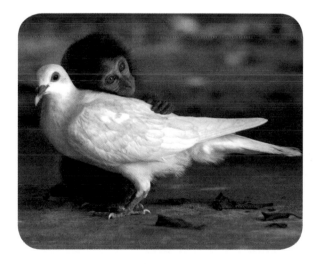

by

JENNIFER S. HOLLAND

WORKMAN PUBLISHING · NEW YORK

"If two lie together, then they have warmth;

but how can one be warm alone?"

—Ecclesiastes 4:11

Contents

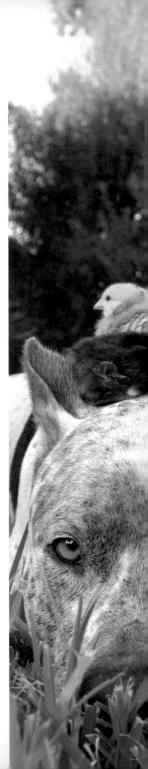

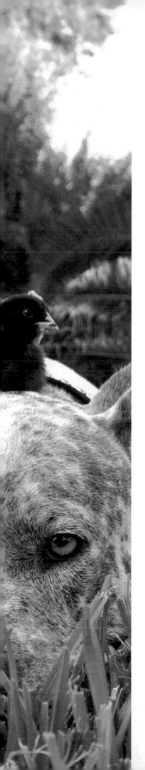

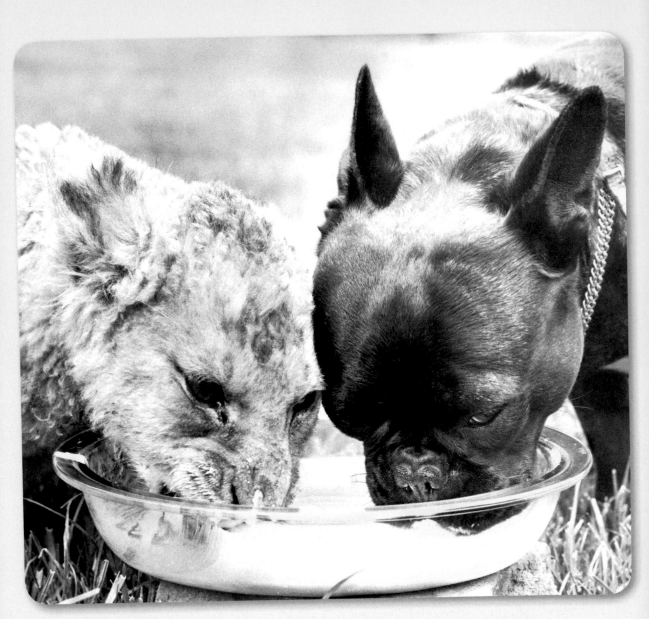

A lion cub and a French bulldog share a drink together at Twycross Zoo in the U.K.

Introduction

MY HUSBAND JOHN'S FIRST BEST FRIEND WAS A RACCOON. When a stray cat dropped the tiny fur ball into a neighbor's boot, ten-year-old John became the creature's caretaker, cupping it in the palms of his hands, dripping milk into its mouth with an eyedropper, and tucking it into a blanketed box at night, with a ticking clock to mimic a mother's heartbeat. John named the animal Bandit, and the raccoon grew up following him everywhere—as he left for school, to the dinner table, even into the shower. Bandit sat on John's shoulder, shirt collar in its tiny grip and face into the wind, as the pair whizzed down the street on John's bike. And the raccoon slept curled up on John's pillow, cooing its animal dreams softly in the child's ear. No word but friendship could describe the bond shared by boy and raccoon.

It isn't unusual for human beings to connect with other

animals. Well over half of all U.S. households keep pets, spending more than $40 billion a year on their welfare. Studies show that encounters with pets can lower blood pressure, ease depression, and soothe the mental and physical pain of growing old—just a few of the countless ways animals enrich our lives.

Less common than a human–pet connection, and at first glance more surprising, is a bond between members of two different nonhuman species: a dog and a donkey, a cat and a bird, a sheep and an elephant. The phenomenon is most often reported in captive animals, in part because we simply catch them in the act more often. But it's also because, notes biologist and primate specialist Barbara King of the College of William & Mary, that's where constraints are relaxed, where the animals aren't fighting for their basic needs—which allows their emotional energy to flow elsewhere. Of course, there are cases of cross-species bonds in the wild, as well. "Most important," King says, "we know animals, under whatever circumstances, have that capacity."

Not all scientists are comfortable using a term like friendship when referring to nurturing or protective animal relations. For many years, "animals were to be described as machines, and students of animal behavior were to develop a terminology devoid of human connotations," wrote primatologist Frans de Waal in *The Age of Empathy*. He himself has been criticized for attributing human traits to animals by biologists who believe

"anthropomorphic anecdotes have no place in science."

Even those less averse to associating people-based ideas with nonpeople say we don't know how much awareness exists between "friends" regarding their behavior. But behaviorists argue that declaring that there is none at all leans too far the other way. The famed primatologist Jane Goodall, who has described her own relationship with wild chimpanzees as friendships, said in a recent interview with me for *National Geographic*, "You cannot share your life in any meaningful way with an animal and not realize they have different personalities. Are their capabilities and emotions similar to ours? Absolutely."

On a Darwinian note, evolutionary biologist Marc Bekoff of the University of Colorado, who has written extensively on animal sentience, puts it like this: "Evolutionary continuity—a concept that came from Charles Darwin—stresses that there are differences in degrees rather than in kind between humans and other animals. That applies to emotions. We share many bodily systems, including the limbic system, where emotions are rooted. So if we have joy or sorrow, they have it, too. It isn't the same joy or the same sorrow. But the differences are shades of gray, not black versus white." Nurturing feels good to us, Bekoff says, so why wouldn't it feel good across species?

Feeling good is what this book is about. These stories represent just a small sample of the unexpected animal pairings that

people have reported around the world. Dogs, not surprisingly, feature prominently: One dog mothers a baby squirrel, another parades around with chicks on his back, a third buddies up with an elephant, for example. But I have sought out a mix of species to reveal the wide reach of this phenomenon. I describe the unions as friendships, knowing that we can't truly explain what emotional strings bind our nonhuman kin but assuming that there is some parallel to our experiences. To me, friendship is as simple as seeking comfort or companionship from another to improve one's own life experience. Even if friendship is had only briefly, it is a plus. And in all of the cases that follow, the animals involved are arguably better off—more confident, physically stronger, in higher spirits—after finding each other than they were before.

Though my focus is on pairs of nonhuman animals, during my research I stumbled across many extraordinary stories about people bonding with other species. That's a subject for another book, but I picked a couple of favorites to include here in the mix.

Why do unlike creatures get together? Often biologists can point to an obvious benefit to one or both animals related to spotting predators, keeping parasites at bay, staying warm, finding food. Scientists label such relationships with terms like commensalism or mutualism. This book is concerned with cases that are a little less tidy. Some involve an animal taking a parental or protective role toward another, probably instinctively. Others have no obvious explanation. Perhaps the need for a good friend is not just

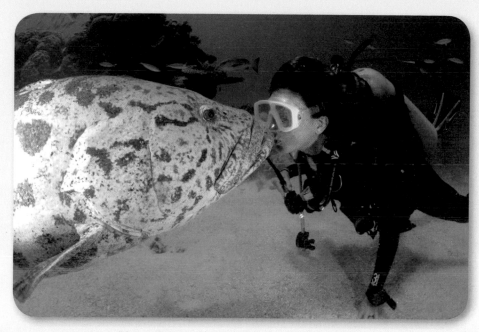

The author befriends a potato cod in Australia.

a human thing after all.

What *is* human is to experience the *awwwww* factor of an ape hugging a kitten or a puppy nuzzling a pig. We are built to melt over soft, cuddly things (it's one reason we can endure the stress of parenting a newborn). But the appeal goes deeper, Barbara King says: "I believe people crave examples not just of cuteness, and not just of tolerance—but of true compassion and sharing. These stories help us get in touch with the best in ourselves."

. . .

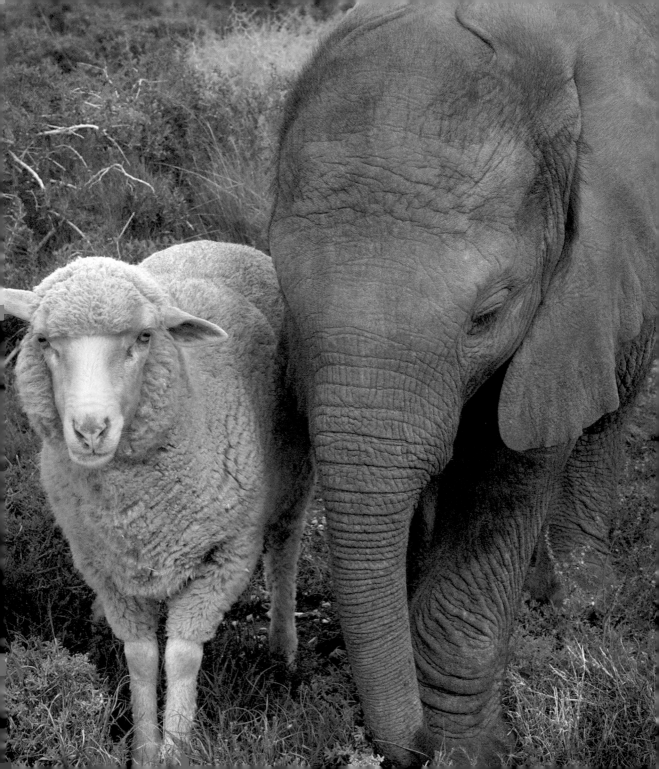

The African Elephant
and the Sheep

AT JUST SIX MONTHS OF AGE, THEMBA THE ELEPHANT suffered a terrible loss: His mother fell off a cliff while moving with their herd through the South African nature reserve where they lived. At such a critical time for mother–son bonding, veterinarians hoped another female in the herd would adopt the baby, but none did. So they decided to find a surrogate outside the elephant family to help Themba.

Staff at the Shamwari Wildlife Rehabilitation Center in Eastern Cape had been successful keeping a motherless rhinoceros with a sheep. Hoping for a similar triumph, wildlife managers moved Themba to the Rehabilitation Center and borrowed a domestic sheep named Albert from a nearby farm.

AFRICAN ELEPHANT

KINGDOM: Animalia
PHYLUM: Chordata
CLASS: Mammalia
ORDER: Proboscidae
FAMILY: Elephantidae
GENUS: Loxodonta
SPECIES: L. africana

Why a sheep? They might not seem like the brightest of animals, but in truth their intelligence falls just below that of pigs, which are quite smart. They can recognize individuals over the long term, can distinguish between different emotions based on facial expressions, and will react emotionally to familiar faces of various species. So bonding with other kinds of animals might not be so unlikely—especially with elephants, who are unquestionably bright and expressive, and rely heavily on social bonds.

Still, the attempt to pair the two species didn't start out well. When first introduced, Themba chased Albert around the watering hole, flapping his ears and lifting his tail to look as large and threatening as possible. Albert fled, as sheep instinct demands, and hid for hours. Over three days of wary gestures and tentative touches, the pair finally accepted each other, and the result proved well worth the stressful beginning.

"I still remember the day Albert took the first leaves off a tree where Themba was feeding," says Dr. Johan Joubert, the center's wildlife director. "We knew they truly bonded when they started to sleep cuddled up together. I must admit, we were concerned that Themba would lie down on top of Albert and crush him by mistake!"

Once the bond took hold, elephant and sheep were inseparable. They'd nap in tandem, horse around

DOMESTIC SHEEP

KINGDOM: Animalia
PHYLUM: Chordata
CLASS: Mammalia
ORDER: Artiodactyla
FAMILY: Bovidae
GENUS: Ovis
SPECIES: Ovis aries

together, and Themba would rest his trunk on Albert's woolly back as they explored their enclosure or went in search of snacks. Though keepers expected Themba to imitate the elder Albert, instead the sheep became the copycat, even learning to feed on Themba's favorite leaves—from a thorny acacia plant not typically part of a sheep's diet.

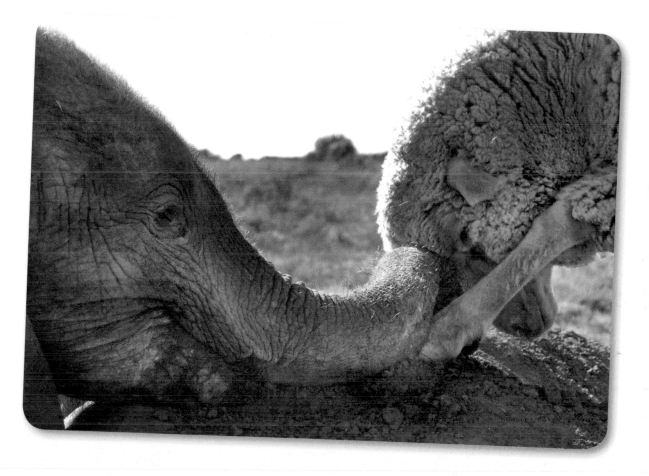

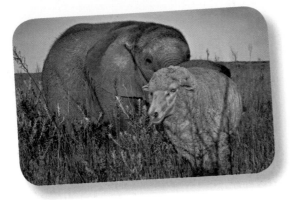

Johan Joubert and his staff had always planned to reintroduce Themba to his family in the reserve where he was born. But during preparations for his release, Themba became ill from a twisted intestine and veterinarians were unable to save him. He was just two and a half years into what might have been a seventy-year lifespan.

The staff at the wildlife center were heartbroken, though Albert, fortunately, was able to forge new interspecies friendships among the reserve's zebra foals and wildebeest.

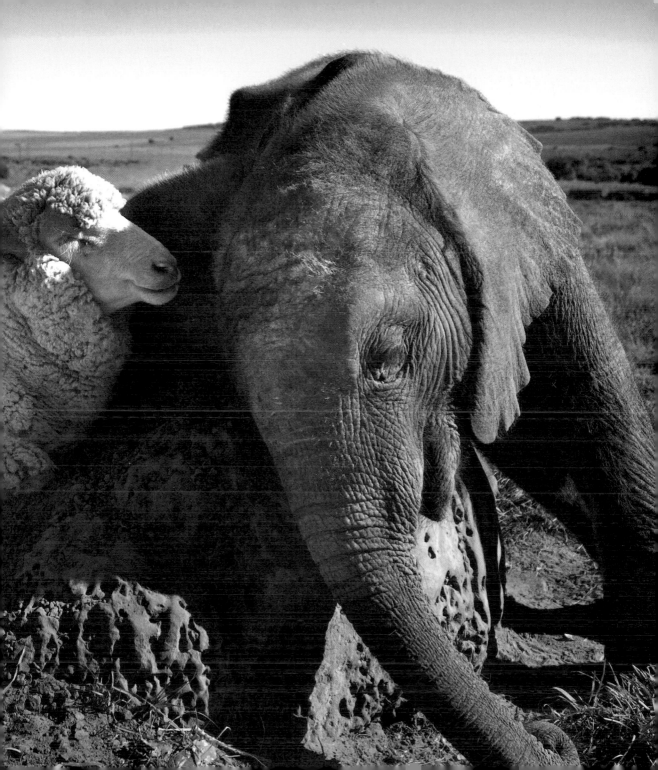

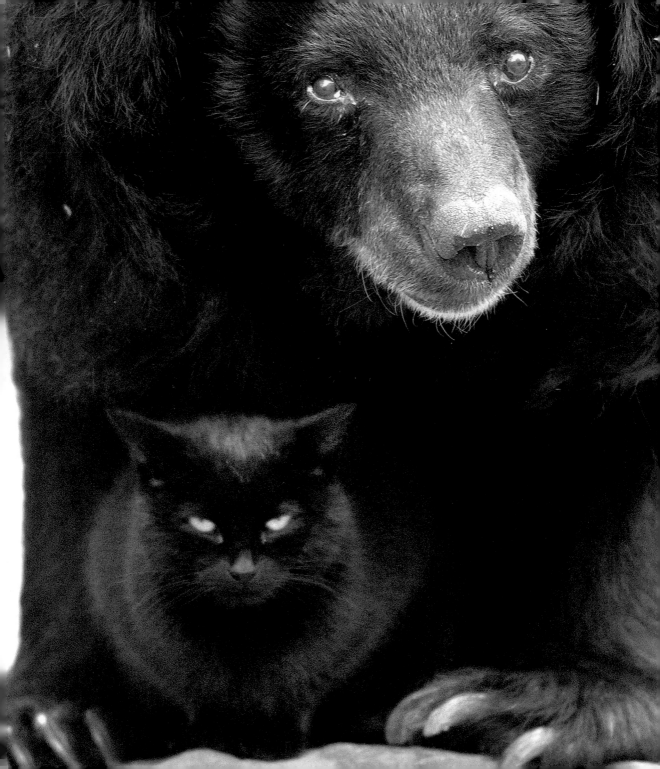

The Asiatic Black Bear
and the Black Cat

FROM THE LOOK OF THINGS, THERE'S SOMETHING ABOUT these two glossy black mammals with matching perked-up ears and mellow attitudes that just says *family*. But the smooth-haired domestic cat and the shaggy Asiatic bear share little DNA. Dogs are more closely related to bears than cats are. So in the case of Muschi the cat and Mausschen the bear, blood ties don't bind them. Something else keeps them together.

No one at the Berlin Zoo, where Mausschen has been housed for over forty years, knows where Muschi came from. "We observed her back in 2000 suddenly living in the black bears' enclosure, and she'd struck up a friendship with the old lady bear," says curator Heiner Klös. "It's unusual to see this kind of relationship between two

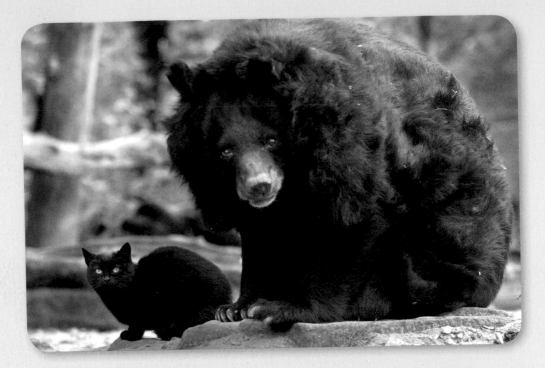

unrelated carnivores, and visitors love to observe them together."

Mausschen is the oldest known female Asiatic bear. She is a member of a medium-sized forest species whose wild habitat includes parts of Afghanistan, the Himalayas, mainland Southeast Asia, the Russian Far East, and Japan. She has spent her life well cared for in captivity. On any given day, she might be seen sprawled out in a bed of hay with Muschi by her side or lying with the cat in the sun, the two absorbing the day's warmth together. They go halves on meals of raw meat, dead mice, and fruit. And during a period of separation, while the bear exhibit was

DOMESTIC CAT

KINGDOM: Animalia
PHYLUM: Chordata
CLASS: Mammalia
ORDER: Carnivora
FAMILY: Felidae
GENUS: *Felis*
SPECIES: *Felis catus*

renovated, the cat seemed troubled and waited around until she could be reunited with Mausschen. Zoo staff encouraged the reunion after seeing how content the animals were in concert.

Muschi can come and go from the enclosure as much as she likes, "but she always comes back to the old bear," Klös says. Their unusual relationship has lasted a decade, and there are no signs of a parting.

ASIATIC BLACK BEAR

KINGDOM: Animalia
PHYLUM: Chordata
CLASS: Mammalia
ORDER: Carnivora
FAMILY: Ursidae
GENUS: *Ursus*
SPECIES:
Ursus thibetanus

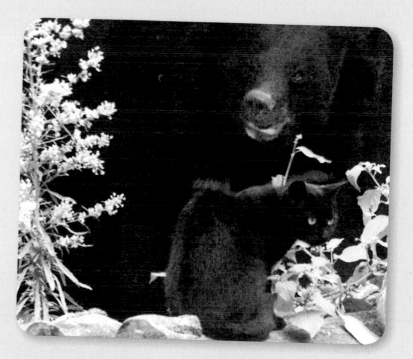

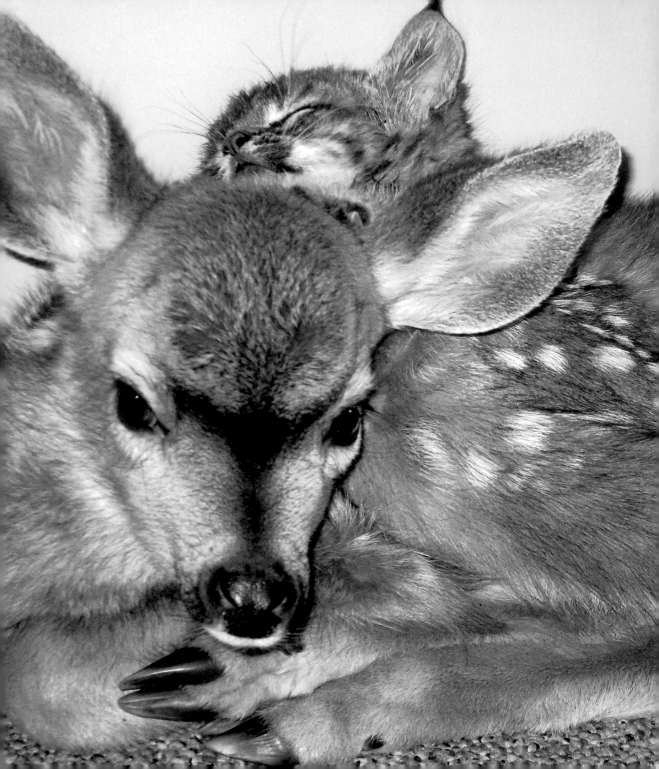

The Bobcat Kitten

and the Fawn

FIRE IS NO FRIEND TO WILDLIFE. IN ANY GIVEN YEAR IN California alone, there may be fifty or more big blazes a month that destroy hundreds of acres of habitat, displacing animals by the thousands. Many perish in the flames or after, from stress or dehydration.

But some lucky ones are rescued.

That's what happened to a tiny fawn and a young bobcat during a major fire near Santa Barbara in 2009. It was May, when many animals give birth, so the California forests were filled with wobbly-legged newborns. Other fires had already destroyed vast tracts of wildland that year, so surviving animals were extra vulnerable. The May fire was devastating. When rehabilitators from the

CALIFORNIA MULE DEER

KINGDOM: Animalia
PHYLUM: Chordata
CLASS: Mammalia
ORDER: Artiodactyla
FAMILY: Cervidae
GENUS: Odocoileus
SPECIES: Odocoileus
hemionus californicus

Santa Barbara Animal Rescue team picked up a particular young deer, it was weak and wandering in the area where the fire had started, crying and alone.

Because of the number of orphans being rescued, space at wildlife centers was scarce, so the sheriff's department offered its facility as temporary housing.

"We had a tiny kitten, a bobcat, already in a crate there," says Julia Di Sieno, director of the team. "We had rescued him on the governor's property, and the animal needed round-the-clock care. We weren't sure he'd survive." When she brought in the fawn, she found that crates, like rehab space, were in short supply. There was no choice but to put the two young animals together. And that turned out to be just what they needed.

"As soon as we let the fawn in, the bobcat went right over to her, curled up, and went to sleep. They were both so exhausted and weak. They cuddled right up as one." The animals were only together for a couple of hours while rescuers found room for the fawn a few hours away, "but it was such an impor-tant time," she says. "It offered them both warmth and comfort, and maybe alleviated their fear and loneliness. It was such a lovely bond."

The rescue group, which on this occasion saved wildlife and domestic animals of all sorts,

BOBCAT

KINGDOM: Animalia
PHYLUM: Chordata
CLASS: Mammalia
ORDER: Carnivora
FAMILY: Felidae
GENUS: Lynx
SPECIES: Lynx rufus

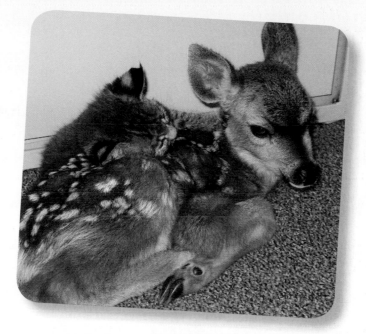

rehabilitates everything from ducks to foxes and, eventually, releases them into areas where habitat remains intact. After its much-needed rest with its bobcat friend, the fawn was relocated and placed with other fawns so it would grow up with its own kind. Months later, when the fawn was a year old, the deer herd was set free.

"It's funny because a fawn would normally be a nice little morsel of food for a bobcat—an adult bobcat, that is," says Di Sieno. Indeed, the cat, still in captivity for the time being, has since become a stealthy and successful hunter. But under the stress of the fire, the two natural foes found strength in each other. "I'm sure it boosted their morale to be together at that critical time," Di Sieno says.

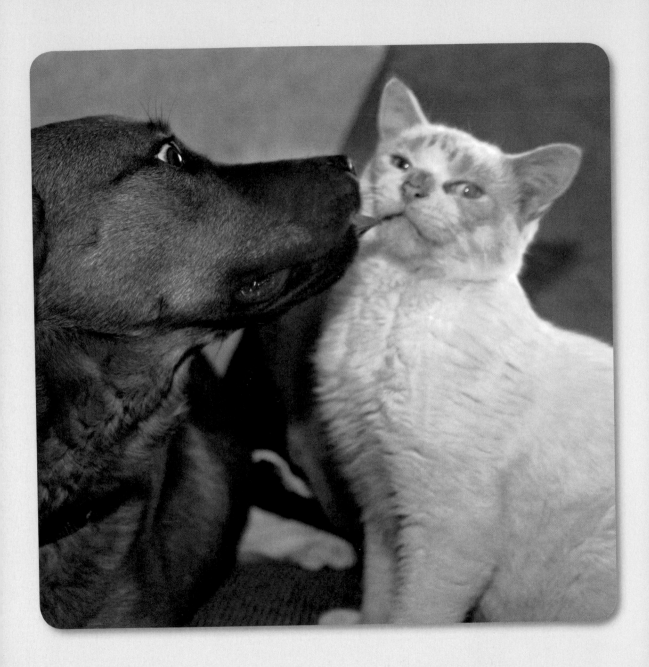

The Bobtailed Dog and the Bobtailed Cat

WHEN HURRICANE KATRINA SLAMMED INTO NEW Orleans, Louisiana, in August 2005, thousands of pet owners were forced to rush to high ground without their animals. Most left food and water to tide their pets over, expecting to collect them within a day or two. But few were able to return home, and at least 250,000 domestic animals were suddenly on their own.

Scores of pets died. Many hit the streets, relying on their most basic instincts to survive. Some joined packs for protection. These two found each other.

The dog, a female, had a bobbed tail. So did the cat, a male. The dog had been tied up but had broken away, and a few links

of chain still hung down from around her neck. The cat followed the clinking strand as it dragged on the ground. They were likely wandering the city that way for many weeks. No one knows if they shared a home before the storm, but when a construction worker first took an interest in the animals, they were clearly together. In fact, the dog was quite protective of her feline friend, growling if anyone got too close to him.

Rescuers from Best Friends Animal Sanctuary brought the pair to a temporary shelter in Metairie, a New Orleans suburb, and named them Bobbi and Bob Cat, for the cropped tails.

"We were set up to house dogs and cats separately," says the sanctuary's Barbara Williamson, who handles media relations and also helped watch over the two Bobbies after their capture. "But Bobbi wasn't having it. She had a piercing bark that would go right through you. And as long as they were separated, she got very upset and loud." So the volunteers cobbled together a cage inside a longer cage, to give the animals access to each other without taking a chance on either getting hurt. "As long as Bobbi was near her kitty, she was calm," Barbara says.

The discovery that Bob Cat was fully blind, probably since birth, made the animals' relationship all the more touching. Bobbi the dog had truly been leading him and keeping him safe. "You could tell by

DOG

KINGDOM: Animalia
PHYLUM: Chordata
CLASS: Mammalia
ORDER: Carnivora
FAMILY: Canidae
GENUS: Canis
SPECIES: Canis lupus familiaris

the way she managed his movements," Barbara says. "She'd bark at him, as if telling him when to go and when to stop. She'd bump her hind end against him, herding him the right way. It was incredible to watch." Despite his handicap, Bob Cat "was very confident, almost regal," Barbara says, "while Bobbi was more of a clumsy teenager. The contrast was a riot."

According to the Humane Society of the United States, 6 to 8 million stray dogs and cats end up in animal shelters each year. Of these, approximately half are euthanized.

News about the dog–cat duo quickly got out through the media, and Best Friends found just the right person to take these special animals. But sadly, not long after the adoption, Bob Cat became ill and died. The new owners decided the best medicine for the dog was to bring another rescue cat into the household, and they found one that, coincidentally, had a cropped tail. Bobbi the dog accepted the new feline right away.

"For me, the Bobbies demonstrated the depth of feelings animals can have for one another," says Barbara.

Luckily, that emotional depth does at times include humans. The pet salvage operation after Katrina was one of the largest ever accomplished following a natural disaster. Caring volunteers and rescue organizations worked tirelessly to help find new homes for thousands of animals.

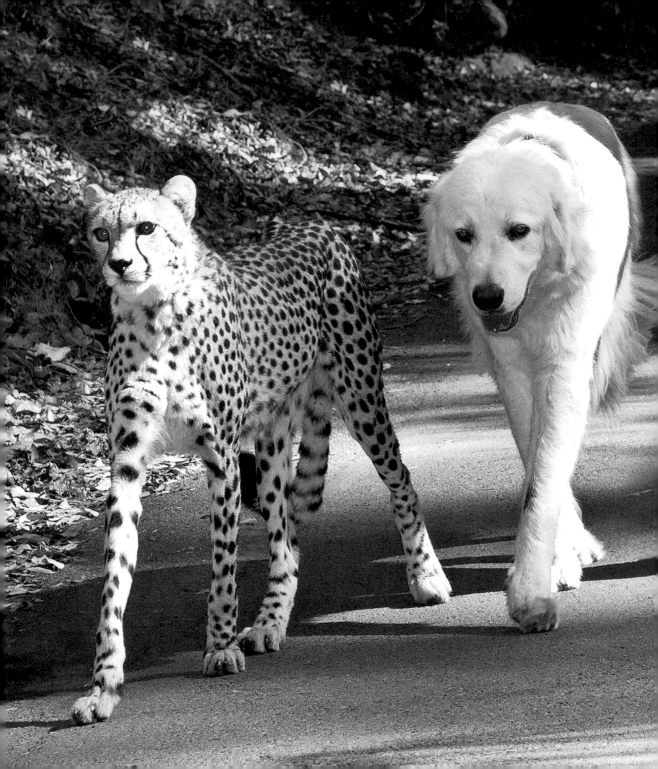

The Cheetahs and the Anatolian Shepherds

IN THE AFRICAN COUNTRY OF NAMIBIA, WHERE FARMERS and ranchers eke out a living on parched sandy soils, the cheetah is no friend to man. Livestock is a big and tasty temptation to the wild cats, especially during times of drought, when natural prey on the savanna is scarce. And when cheetahs come after livestock, people often shoot them, driven to protect their valuable resource.

The Cheetah Conservation Fund came up with an inspired alternative: offer dogs to farmers to be raised as guardians of the flocks. Anatolian shepherds, first bred in central Turkey thousands of years ago, were chosen for the job. The dogs are big and loyal, and know how to scare off an already skittish cat like a cheetah. (Wild cheetahs face formidable foes in nature; their ability

and readiness to sprint is their best defense.) Keeping the cheetahs from preying on sheep and goats protects them from farmers' bullets and helps take the stain off their reputation—both good strategies for keeping the species around in the future. The program has been wildly successful.

Now, here's a neat little twist: At zoos in the United States, those same shepherd dogs are being brought in not to chase cheetahs away, but to be their best friends.

"We've found so many benefits to pairing young cheetahs with domestic dogs," says Kim Caldwell, animal training manager at the San Diego Zoo's Safari Park. Foremost, as they grow up together, the dog is a security blanket for this animal that's hardwired to be cautious, she says. Body language is key, and the dog—calm, loving, and adaptable—helps the cheetahs to relax and accept unfamiliar situations. That makes life less stressful for both the animals and the trainers. "Cheetahs respond differently to us than to another four-legged furry animal with a wagging tail," Kim says. "A dog will lick the cheetah's ears, let it pounce, and chew on him. Better to give the cats a 130-pound dog as a toy than one of us. That way they can really wrestle and play together, which is an important part of learning and socialization."

The San Diego Zoo and Safari Park have also

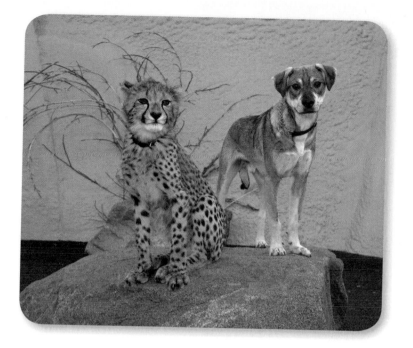

used various mixed-breed pups in their cheetah program, but the shepherds are the best fit. "Some mutts can be just unstoppable," Kim says. The shepherds are very mellow as puppies. Though always ready to roughhouse, they'll also lie down like a big rug and groom or be groomed—which cheetahs do a lot of the time. "Remember," Kim says, "while most dogs could play twenty-four hours a day, cats want to sleep for twenty of those!"

The animals do have some time apart, and they always eat separately. "Dogs inhale and cats chew," Kim says, so feeding time is where aggression could occur. But once a happy pairing is made between puppy and kitten, "they're companions for life."

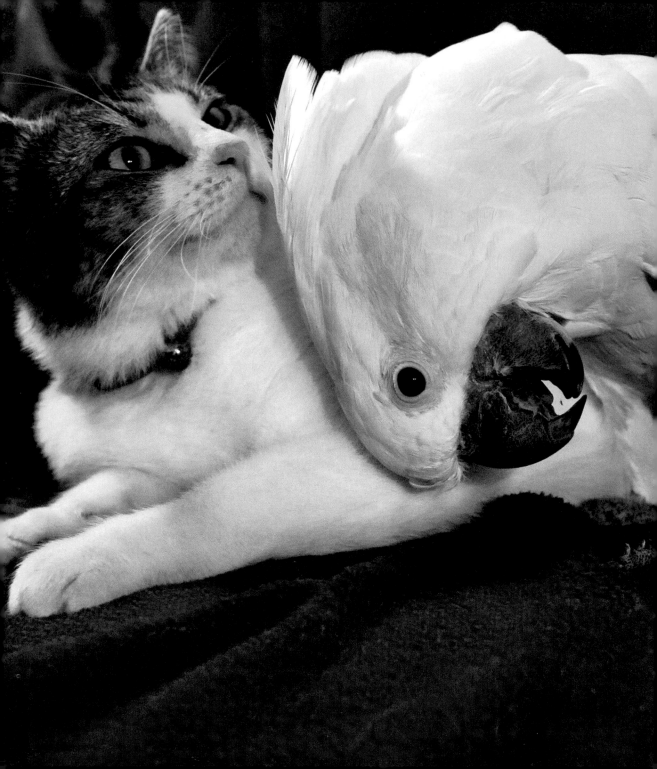

The Cockatoo
and the Cat

SCRATCH A CAT BEHIND THE EARS AND MAKE A FRIEND for life. But what if the one doing the scratching has feathers, a beak, and bird feet? That doesn't seem to bother Lucky, a young stray cat that was fortunate enough to be rescued by Libby Miller and Gay Fortson of Savannah, Georgia. After his adoption, Lucky found himself cohabitating with Coco, a brash and outspoken cockatoo that took to the feline with a gentle claw.

Coco was perched on the foot of the owners' sleigh bed one morning, and Lucky, who had not yet met the bird up close, must have been hiding under the bed. When Libby came into the room, "there they were, together on the bed." She worried for a moment that one would hurt the other, but "Coco was being so gentle! She

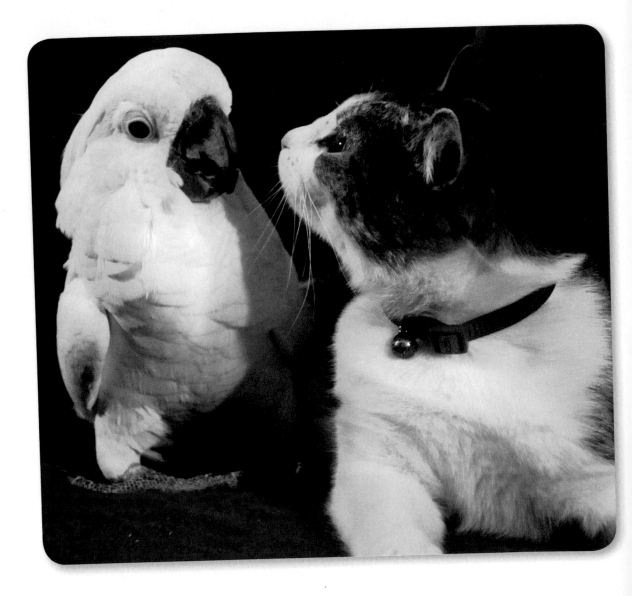

rubbed Lucky with one foot, then walked back and forth over her head—which Lucky didn't seem to mind at all." Libby grabbed her camera and recorded the strange interaction. The video eventually made it to the Internet and has since gone viral. "People all around the world love seeing how they get along," she says.

WHITE COCKATOO

KINGDOM: Animalia
PHYLUM: Chordata
CLASS: Aves
ORDER: Psittaciformes
FAMILY: Cacatuidae
GENUS: *Cacatua*
SPECIES: *Cacatua alba*

The two animals continue to be affectionate housemates, despite the bird's potential to do harm with her strong beak and claws. Coco sticks her fingerlike tongue in the little cat's ear, or kneads and nuzzles her, seemingly fascinated by the taste of the soft fur and squishy feel of the body. And Lucky, realizing a good thing, rolls over and offers up her belly to encourage the massage.

At the end of the day, the cat–bird pair happily sits in one of their owners' laps together, "just chilling out," along with the couple's four dogs. The night doesn't feel right until their pets have all been let out to bond with one another, the ladies say. "We just love that our animals love being together."

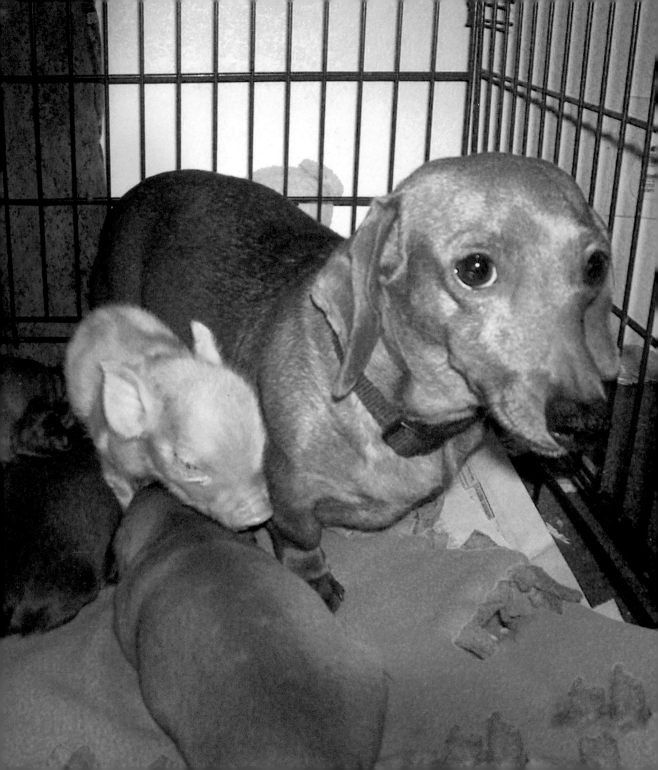

The Dachshund

and the Piglet

ONE BONE-CHILLING NIGHT, ON A BED OF STRAW IN A **WEST** Virginia barn, a very lucky pig was born.

Pink was a runt by all measures. When he was born, neither Johanna Kerby, who helped the sow deliver the litter that night, nor her husband and daughter, who were watching, thought the tiny piglet would survive outside his mother's womb. Luckily, Pink was given a chance at life by an unlikely benefactor.

Of a litter of eleven, Pink was the last to emerge, and it was immediately clear he wasn't like his brothers and sisters. Pigs are normally born with their eyes open, and it takes just a minute before they are walking and nursing. They're also about three to four pounds. Pink was less than a pound, with his eyes sealed shut

against the world. He was frail, virtually hairless, his tiny voice barely a squeak. "He just lay in the box and quacked," Johanna recalls. "He didn't even try to walk. He was just too weak." When she held the baby to his mother's teat to nurse, he wouldn't suck. And soon enough, his stronger siblings were pushing him around, trying to get Pink out of the bed, to rid themselves of their weakest competitor.

DOMESTIC PIG

KINGDOM: Animalia
PHYLUM: Chordata
CLASS: Mammalia
ORDER: Artiodactyla
FAMILY: Suidae
GENUS: Sus
SPECIES: S. domestica

Johanna had an idea. The family dog, a small red dachshund named Tink, had always been loving to people and maternal to other animals. And she had a thing for pigs.

The first time Tink was introduced to piglets, years before in the Kerbys' hog barn, "she rounded them all up into a corner and starting licking them," Johanna recalls. "They were twenty-five pounds, much bigger than she was, but Tink didn't care. She was so happy and wiggly—she had a great big grin on her face." Another time she nearly drowned in the soupy, thick mud of the hog pen when she ventured in, just to get near the animals.

DACHSHUND

First bred in Germany in the 1600s, the dachshund's long, low body and keen sense of smell made it ideally suited to hunting badgers hiding inside their burrows below ground.

Tink had given birth to two pups herself recently, but one had been stillborn, and she was clearly distressed by the loss. Johanna decided to put Tink and Pink together and see if the pup would accept the pig as just another offspring. The same trick had worked recently with another dog's puppies;

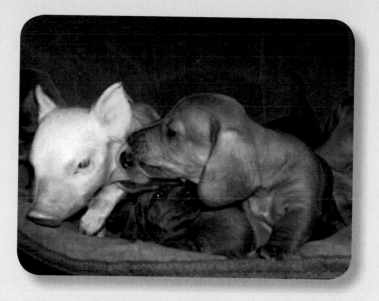

Tink had happily tucked them in among her own.

Piglet fostering went as smoothly as the puppy placement had. Once Pink was let into the dog's crate, "Tink went crazy. She licked him thoroughly and even chewed off the rest of his umbilical cord," says Johanna. Then she tucked him under her chin to keep him warm. And when the other puppies were ready to nurse, she used her nose to encourage Pink to join them at her belly.

To the Kerbys' relief, Pink latched on to Tink and began to feed. "Tink treated him like royalty; I think he was actually her favorite," Johanna says. With such special care, Pink soon caught up in size and weight to his siblings, though he was never interested in rejoining the pigs. His family now was strictly canine, and he'd romp and wrestle with the puppies as if nothing were amiss.

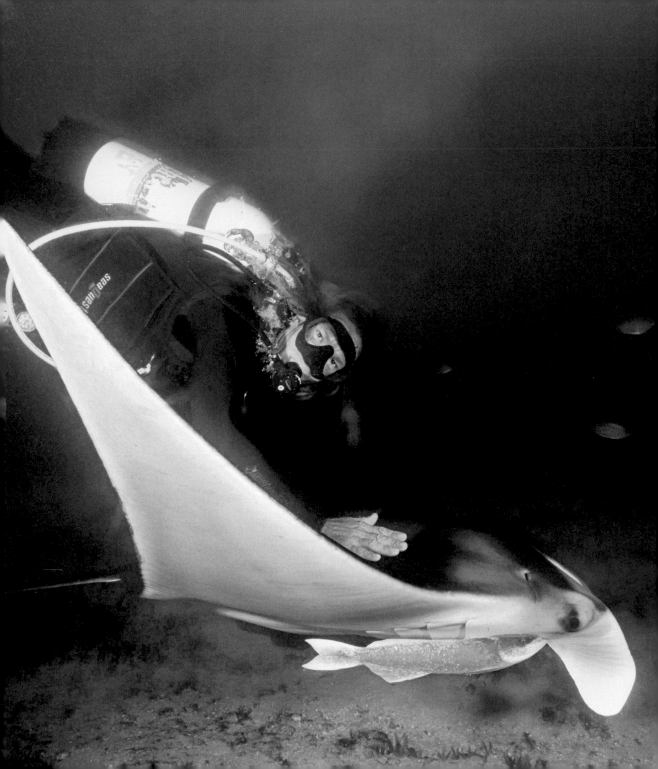

The Diver *and the*

Manta Ray

SEAN PAYNE HAS CLOCKED THOUSANDS OF HOURS SCUBA diving in the sea, happily meeting countless animals eye to eye, from minuscule reef shrimp to colossal whale sharks. But when this dreadlocked boat captain talks about a particular encounter with a manta ray, it's as though he's describing his first love.

He wasn't out looking for rays. Sean was assisting underwater photographers with a project on goliath grouper, a sometimes 800-pound fish that shares the ray's environment off the Florida coast. He was diving at twilight on a shipwreck ninety feet down where the big fish congregate, shaking a rattle used to get the other divers' attention. "Suddenly, I saw this little black ray coming

toward me," he recalls. (Size is relative, of course. Adult mantas, the largest rays, can grow to more than 20 feet across and weigh some 3,000 pounds.) Rays are often curious about divers, but usually the fish will sweep by and land on the sandy bottom out of reach. This one, an adolescent, apparently wanted a massage from human hands.

"She slipped right up underneath me—I actually had to hold her off to keep her from pushing against me from beneath," says Sean. "Her skin felt like velvet cloth stretched over ribs and muscle, an incredible texture." The ray literally danced with the diver, leading him in a bizarre circular tango that forced her body into his hands. As he ran his hands over her skin, her wing tips vibrated like a dog's leg during a particularly good belly scratch. "I was so into the encounter by then, I couldn't tear myself away," Sean says. "The thing about rays is usually you have to chase them just to get a close look. Here was one that approached me on its own; she zeroed in on me and wanted to be touched. It was as if I were petting and meeting eyes with my German shepherd—I felt a real connection between us. Truly awesome."

After a few minutes of man–fish bonding, Sean got the signal to get back to work, and reluctantly he

HUMAN BEING

KINGDOM: Animalia
PHYLUM: Chordata
CLASS: Mammalia
ORDER: Primates
FAMILY: Hominidae
GENUS: *Homo*
SPECIES: *Homo sapiens*

MANTA RAY

KINGDOM: Animalia
PHYLUM: Chordata
CLASS: Chondrichthyes
ORDER: Myliobatiformes
FAMILY: Mobulidae
GENUS: *Manta*
SPECIES: *Manta birostris*

moved away. The young ray—standoffish toward the other divers—stayed nearby. And when Sean headed toward the surface (unlike his ray friend, he needs air from above), she hovered right below him as if making sure he ascended safely.

"I was supposed to be holding underwater lights on the goliath groupers as they spawned, for the photographers, and I missed the whole thing because of the ray," Sean says. "But it was so worth it to have that experience." He named the young animal Marina after his daughter, "my other little girl."

Sean's loving attitude toward the ray might have surprised a seagoer from long ago. In ancient times, manta rays, with their pointy fins, were sometimes associated with the devil, and sailors told tales of the animals leaping from the water and capsizing boats. Although in truth they are peaceful creatures, it's not hard to fathom how these legends were born. With power and grace, mantas will occasionally breach the surface and take to the air, if only for a moment or two, before crashing gloriously back into the sea. Nowadays we see that as beautiful—maybe even playful. But 500 years ago, standing on the deck of a creaky wooden galleon, friendship with one of these winged, "horned" creatures would have been the last thing on your mind.

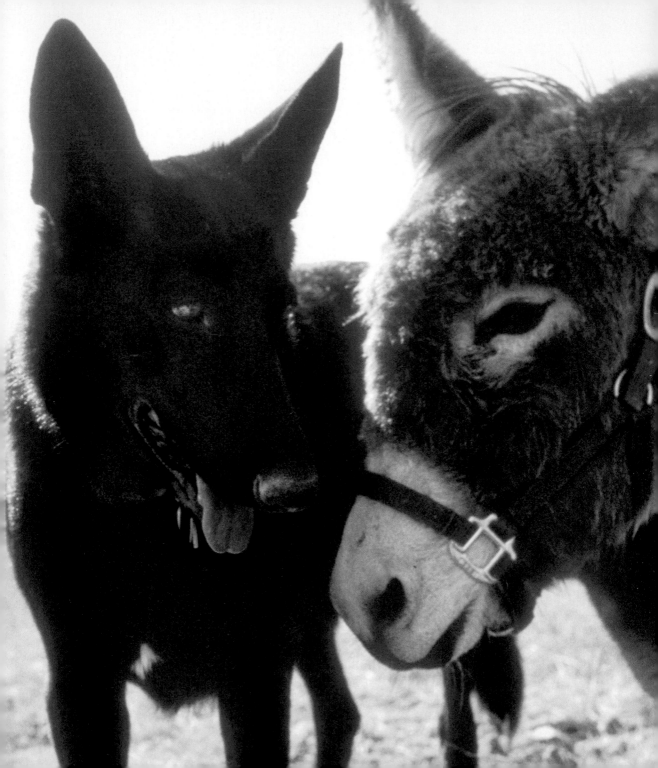

The Donkey *and the* Mutt

SOME FRIENDSHIPS START OUT A LITTLE LOPSIDED BUT soon wobble into balance. So it was with Safi the mutt and her buddy Wister, a young male donkey (or jack) with a reputation for sending canines into hiding, not tempting them into play.

The first time the two met, on remote ranchland in Wyoming, Wister was grazing in a meadow and Safi was on a walk with her owner, Barbara Smuts. Safi approached the unfamiliar creature to investigate. When Wister noticed the dog, he ran at him aggressively, then turned and kicked. Safi danced out of harm's way, then dropped to her haunches to signal her desire to play. But Wister's temper flared again and his sharp feet shot out. It took three air kicks before Safi got the message and backed off.

But Barbara, a biologist who specializes in the study of animal behavior, was intrigued by her pup's fascination with this very different species. So on a day when Wister was safely inside his corral, she gave Safi another try at making friends.

This time, Safi raced up and down the fence, and Wister joined in. Up and back they ran, on parallel paths, the dog sometimes barking or growling as part of her rowdy play, the donkey occasionally offering a startling bray in response. Soon Safi began crossing boundaries and testing limits, diving under the fence and tearing through the corral, darting out the other side when the donkey's attentions got too intense for her.

Then one day after a snowfall, Safi found new confidence and started spending more time inside Wister's enclosure. "She discovered that she could maneuver much better in the snow than the donkey could," recalls Barbara.

Finally, the pair was able to play outside of the corral entirely, running around like crazy, nipping each other's heels and necks, and making mouth-to-mouth contact. They started drinking from the same bowl and napping together. When Barbara and Safi hiked, Wister followed along. And when Wister was put to pasture each day, he'd come looking for his friend. "At 5:30 in the morning, he'd bray outside the door where Safi and I slept," Barbara recalls. "It was

MUTTS
According to many veterinarians, mixed-breed dogs (or mutts) usually live longer and are healthier than purebreds.

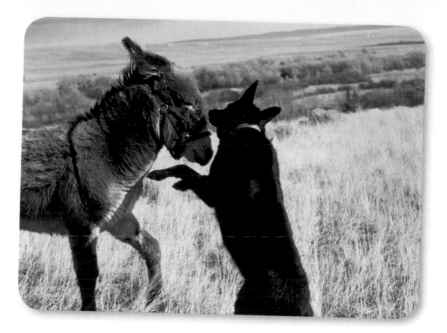

quite an alarm clock. I'd let Safi out to play and go straight back to bed."

After four months, Barbara's sabbatical ended and she had to leave Wyoming, which meant Safi had to say good-bye to his friend. "We went back to our regular life, and Safi adapted quickly to playing with her old canine friends," Barbara says. But Wister, with no other playmates to turn to, suffered the loss greatly. He stopped eating, lost weight, and stood in his corral with his head hung low, uninterested in anything around him. "It showed how truly emotional the donkey–dog relationship had been," says Barbara.

Concerned for Wister's happiness and health, his owners finally got him a female donkey (a jenny) for companionship. That's a very effective way to get an adolescent male mammal's attention, Barbara says. "Not surprisingly, she cheered him right up!"

The Duckling
and the Kookaburra

THE FURRY YELLOWISH ONE THAT WALKS AND TALKS LIKE a duck is a duck. But that other one is a whole different animal.

A six-week-old kookaburra—the largest of the kingfishers, native to Australia and New Guinea—was living solo at the Seaview Wildlife Encounter, located on the Isle of Wight in England. "Our breeding pair of kookaburra has a history of killing its chicks," says the park director Lorraine Adams. Though last year they reared three healthy babies successfully, "this year the female laid three eggs and killed two hatchlings, so we pulled the last one out to save it." The survivor was quickly christened Kookie.

Meanwhile, the staff rescued a tiny Madagascar teal duckling,

KOOKABURRA

KINGDOM: Animalia
PHYLUM: Chordata
CLASS: Aves
ORDER: Coraciiformes
FAMILY: Halcyonidae
GENUS: *Dacelo*
SPECIES:
Dacelo novaeguineae

unable to defend itself against larger birds, from one of the park's aviaries. And Lorraine decided rather than keep the duckling in one enclosure and the kookaburra in another, why not place them together for companionship? As an adult, a kookaburra wouldn't hesitate to eat a little duck, but as a young bird the meat-eater is pretty harmless.

At that point, Kookie wasn't doing much with his days. "Mostly he just sat in his brooder and waited to be fed," Lorraine says. "When I first put the duckling in, Kookie just continued to sit there. The new arrival immediately cuddled right up, trying to get under Kookie's wing to warm up as he would do if his own mother were there." Though not terribly responsive, Kookie showed no aggression, so Lorraine felt the experiment was going well.

Still, she thought it best to separate the animals for the night. But when she took the duckling away and put it in a separate brooder, "it jumped up and down at the door, wanting to get back in with Kookie," she says. In the morning, when the two were reunited, the duckling went right back to cuddling with the larger bird.

Since then, two more ducklings from the same mother have hatched, giving Kookie triplets to contend with. "It's quite an unusual and amazing sight to see three ducks disappear underneath him," Lorraine says. They don't share food: Ducklings eat a mix of crumbs and egg,

MADAGASCAR TEAL DUCK

KINGDOM: Animalia
PHYLUM: Chordata
CLASS: Aves
ORDER: Anseriformes
FAMILY: Anatidae
GENUS: *Anas*
SPECIES: *Anas bernieri*

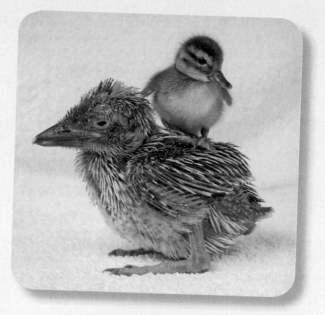

while Kookie feasts on dead chicks, mealworms, and minced beef. But when they're not busy foraging, the ducks "are all over Kookie, climbing on his back, sitting on him, or poking their beaks into his feathers and pushing their way under his wings." Kookie stays put like a good babysitter, taking it all in stride.

Kookaburras are known for their call: The birds will throw back their heads and out will fly a high-pitched cackle that could easily be taken for hysterical human laughter. "When the adults kick off laughing, they can be heard all over the park," Lorraine says. But in youth, the birds have little to say. So far Kookie, despite the circus of activity in his pen, only makes a back-of-the-throat gurgling noise, she says. Perhaps soon he'll let loose with his first wild guffaw, giving his little teal friends a feather-raising surprise.

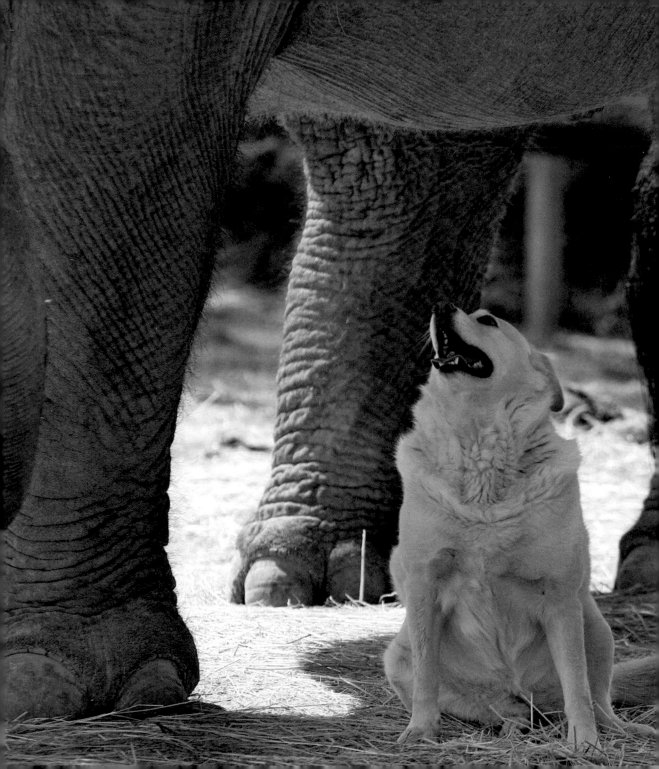

The Elephant and the Stray Dog

AT THE ELEPHANT SANCTUARY IN HOHENWALD, TENNESSEE, elephants brought together from different parts of the world tend to find a friend among the masses—not surprising for social animals used to life in a herd. Stray dogs, common on sanctuary property, typically ignore the elephants, remaining solo or pairing off with their own kind. Then came a female elephant named Tarra and a male dog named Bella to break the mold.

Stepping over social traditions, these two intelligent mammals found each other, then rarely parted. The gentle giant and the chubby mutt ate, drank, and slept in tandem. Tarra's tree-trunk legs towered over her canine friend's head, but the two were content as long as they were side by side.

Then Bella the dog grew ill, and the staff of the sanctuary took him inside to care for him. Tarra seemed distressed and stayed near the house where Bella lay as if holding vigil for him. For many days, as Bella slowly recovered, Tarra waited. Finally, the two were reunited. Tarra caressed Bella with her trunk and trumpeted, stamping her feet. Bella, all dog, wiggled his whole body in excitement, tongue and tail in a nonstop wag as he rolled on the ground.

And, in a most remarkable moment, Tarra lifted one immense foot into the air and carefully rubbed the belly of her friend.

Renowned biologist Joyce Poole, who may have logged more hours watching elephants be elephants than anyone on Earth, recalls meeting the pair on a visit to the facility. "I was fortunate to get up close and personal, to see Tarra with both Bella and another dog she'd befriended. She kept trying to cradle the dogs with her trunk. It was delightful to see." But to Poole, such a friendship isn't all that surprising. "We know from our work with elephants, and from our own relationships with dogs, that both animals are very emotional and form close bonds," she says. In the wild, elephants are loyal to tight-knit groups under the influence of a matriarch. They not only adopt one another's young,

THE
ELEPHANT
SANCTUARY

Located in Hohenwald, Tennessee, the Elephant Sanctuary is the largest natural-habitat refuge in the U.S. designed specifically for old or sick Asian and African elephants.

they even mourn their
dead. An elephant like
Tarra, Poole says, who
grew up with a mix of
role models and was
exposed to other species,
"has simply shifted that
attachment to another
kind of animal."

Like Dr. Seuss's fa-
mously committed cartoon
elephant Horton, who sat
in for a wayward mother
bird to hatch her egg, it
appears that Tarra was
"faithful, 100 percent!"

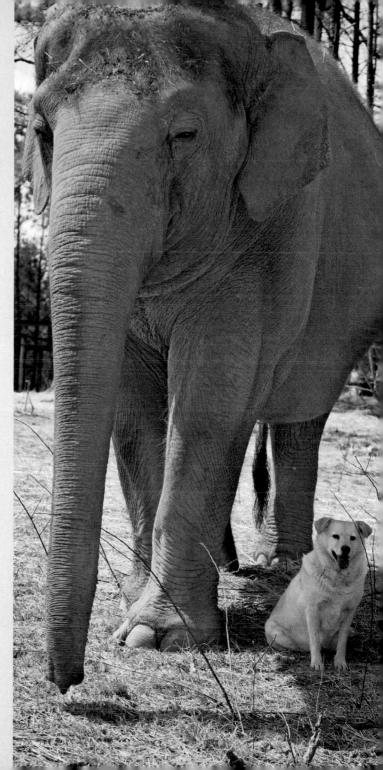

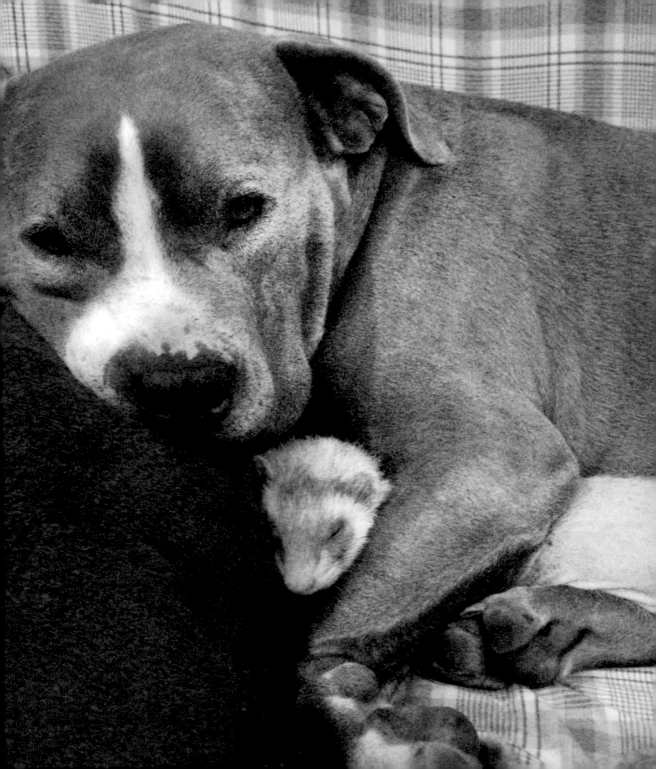

The Ferrets and the Big Dogs

LAURIE MAXWELL IS A CONSUMMATE DOG LOVER. AND she isn't afraid to take on some big ones. Not long ago, two powerful pit bulls and a roll of muscle disguised as a bulldog shared her home. But being of "the more mayhem the merrier" camp when it comes to animals, Laurie decided, why not bring her boyfriend's pair of ferrets into the mix? The rodents added two bolts of lightning to the household. Fortunately, theirs was a positive energy: Moose and Pita quickly became dog lovers, too.

"They were really rambunctious, flying nonstop around the room," Laurie says. And while the two pit bulls were relatively calm, the old English bulldog, Brando, "was rough and rowdy himself. Moose would wrestle with the big beast, biting his jowls and

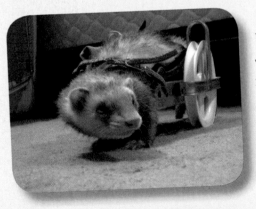

FERRET

KINGDOM: Animalia
PHYLUM: Chordata
CLASS: Mammalia
ORDER: Carnivora
FAMILY: Mustelidae
GENUS: *Mustela*
SPECIES: *Mustela putorius furo*

muzzle," she says. "In reply, Moose would steal Brando's toys, sometimes right out of the dog's mouth, and hide them under the bed. That ferret was a fearless little creature." The two would play tug-of-war with the dog toys, Brando actually lifting Moose off the ground and swinging him around, the ferret gripping the toy in his jaws. "He loved it; he'd go right back for more," Laurie says of the flying Moose, whose neck grew thick with muscle from holding on so tightly.

In all the chaos, Winston, one of the pit bulls, was at first terrified of the ferrets. "If he was on the bed and they scrambled up, he would fall off trying to back away from them," recalls Laurie. But with positive reinforcement, Winston overcame his fear and became the ferrets' favorite pillow at the end of the day. And Nala, pit bull number two, would follow the smaller animals around trying to lick them, like a coach giving his athletes a wipe-down between their bouts of wrestling.

When Moose became ill and lost the use of his back legs, Laurie's boyfriend, Jonathan, made him a tiny wheelchair from a shin guard, a piece of wood, and the wheels from a clothesline pulley. Soon the ferret was back to racing around the house and "off road" in the grass outside with Pita, the two chasing

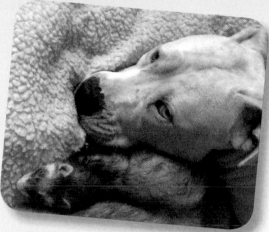

and being chased by a trio of dogs ten times their size.

But then, a few months later, it was Pita whose health began to fail, and she turned into a tiny sack of bones, Laurie says. When she began having seizures, Laurie decided to put her "little winsome ball of fluff" to sleep. Before burying the animal, she let Moose see her. "He nosed her, trying to get her up to play. He laid down next to her and rested his head on her neck." The dogs, too, sniffed at the lifeless creature, uncertain. But their special interest in Moose is what really impressed their owner.

As Laurie later wrote on the website for the Humane Society, where she manages the End Dogfighting campaign, after Pita was gone, the drop in Moose's once-buoyant spirits was obvious to the canines, who tried to help lift them again. "Our spunky dog Nala licked and nuzzled him relentlessly until he warmed up and playfully clawed and bit her giant muzzle," she wrote. "The stoic bulldog Brando followed Moose around the house with a watchful eye. And cuddle-loving Winston curled up and napped with the ferret at night." There was no question in her mind that the dogs, sensing Moose's distress over Pita, were consoling their friend when he needed them most.

THE END DOGFIGHTING CAMPAIGN

This program, created by the Humane Society of the United States, seeks to educate at-risk youth to the dangers and inherent cruelty of dogfighting, a spectator "sport" in which dogs, usually American Pit Bull Terriers, are placed in a pit to fight one another. Dogs used in these events often die.

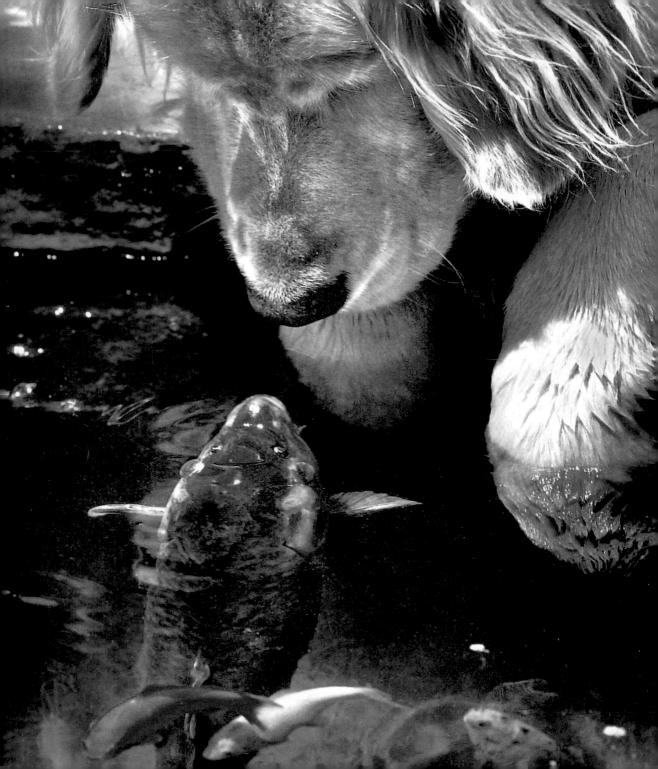

The Golden Retriever and the Koi

HAVE YOU EVER BEEN ENTRANCED AS THE WIND DANCES over water's glassy surface and fish move in perfect unison beneath? A nine-year-old golden retriever named Chino found that enchantment in a suburban backyard pond in Oregon a few years back.

The main draw for Chino was Falstaff, the koi—a large, multi-colored goldfish related to carp, a species that has been selectively bred in Asia for centuries to bring out both beauty and personality. Now popular in Westerners' backyard ponds, koi are as gregarious a fish as you'll find. And Chino was no slouch when it came to social graces.

But no matter how forthcoming, consider the obstacles that

these two animals had to surmount in order to show affection. They couldn't take a walk together, or wrestle, or cuddle, or share a bone. In fact, the only physical contact between dog and fish was one wet nose to another. Yet friends they seemed to become.

Mary Heath and her husband had a backyard pond full of koi. Chino, never particularly interested in other dogs he met on the street, was instead enticed by these unfamiliar creatures and their fluid movement beneath the water. He'd stretch out at the pond's edge on the warm rocks, watching as the fish circled and descended and rose up to feed.

The dog's interest grew when the Heaths moved to a new home and built a new pond with a great perch for the pup. Just two of their original fish moved with the family, including the large, tame, orange and black beauty Falstaff. With fewer swimmers to distract him, Chino focused on Falstaff, and the two discovered a mutual curiosity. "They'd meet at the edge of the pond, and Chino would lean or lie down and put his nose in the water," says Mary. "They'd touch noses or Falstaff would nibble Chino's front paws." She says Falstaff was one of the few creatures whose presence got a tail wag out of the old dog. "The first thing Chino would do when we let him outside was go look for that fish," she says, "and Falstaff would come right over." Then Chino would lie flat on his belly for a half

hour or more, she says, completely captivated by his water-bound pal.

The fish brain is a tiny thing, and no one really knows whether a carp has the capacity for an experience like friendship. But something brought these unlike animals together day after day. Perhaps it was the food pellets Falstaff knew to expect whenever another species approached the pond. Or maybe the mind of a fish can process more complex concepts than just eat, swim, mate, or flee, especially this type of fish—a genetic far cry from your fancy-tailed carnival prize. In parts of Asia, koi, with their regal beauty, smarts, and strength, represent the ability to overcome adversity and move forward with great courage. For some, they are also symbols of good fortune.

And the golden retriever, well, whatever the brain power, it's hard to find one without a lolling tongue and curious nature, ready to offer a friendly wag of the tail.

GOLDEN RETRIEVER

Known for its intelligence and affectionate nature, the golden retriever is one of the most popular breeds in the U.S.

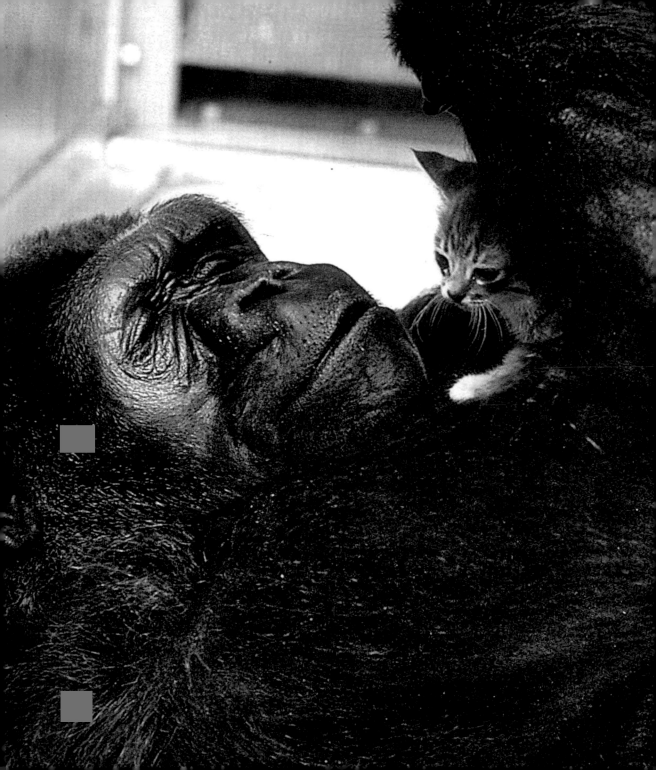

The Gorilla and the Kitten

THIS TALE HAS BECOME A CLASSIC, REVEALING JUST HOW capable of emotion some of our closest nonhuman relatives are.

Koko the gorilla had a best friend that fit in the palm of her hand.

It was 1984 when the 230-pound ape, taught to communicate in American Sign Language, drew two fingers across her cheek like whiskers. It was a signal to her teacher at the Gorilla Foundation, Francine "Penny" Patterson, that she wanted a cat for her birthday. The teacher wasn't surprised; she had been reading to Koko for years, and the ape's most beloved stories were "The Three Little Kittens" and "Puss in Boots." Unfulfilled by a stuffed animal, Koko

was eventually given her pick from a litter of abandoned kittens. She chose a morsel of fur so tiny the gorilla could have crushed him with barely a squeeze. Instead, she cuddled the tailless gray male like a child would a doll, and named him All Ball.

Koko was smitten. She treated Ball as other gorillas treated their babies, carrying him tucked in her thigh, trying to nurse him, tickling and scratching him, even playing dress-up by draping napkins over his body and head. Seeming to know her own strength, she handled him gently, even tolerating his kitten bites without a hint of aggression in return. When asked by her teacher if she loved her little Ball, Koko signed, "Soft, good cat."

The relationship was cut sadly short. The winter after Koko took the kitten in, Ball escaped the gorilla enclosure and was hit by a car. Those working with Koko say the ape's tremendous sadness was clear, revealed in hand gestures, her silent language of grief, and her crying calls.

In a *National Geographic* article about the remarkable ape, her signed words were translated this way:

When asked if she wanted to talk about her loss, Koko gestured: "Cry."

"What happened to your kitty?" her trainer asked.

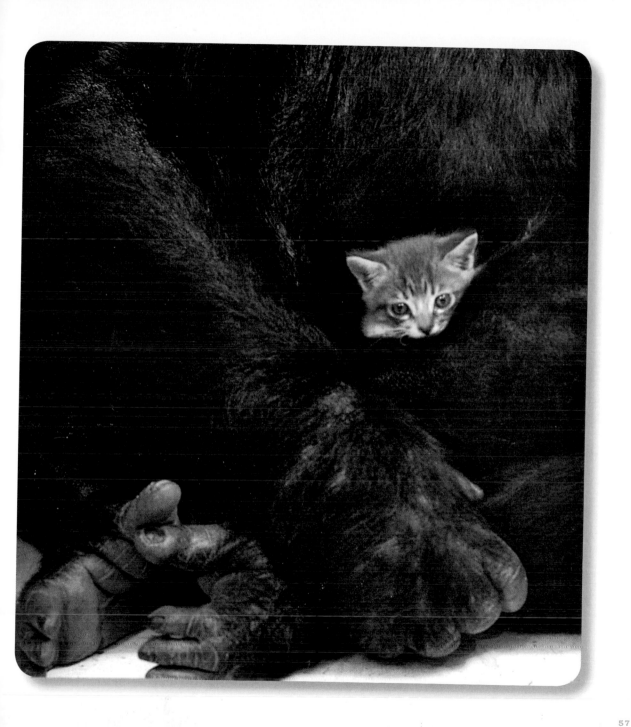

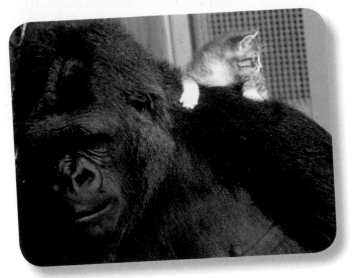

"Sleep cat."

Pointing to a photo of a cat that resembled Ball, Koko's big hands spoke again:

"Cry, sad, frown."

But in gorillas, as in humans, time heals even deep wounds, and there is room in the heart to care for another. Koko soon bonded with two new kittens, Lipstick and Smoky. Her mothering instinct rekindled, the gorilla impressed her human caregivers again by showering gentle affection on animals so unlike herself.

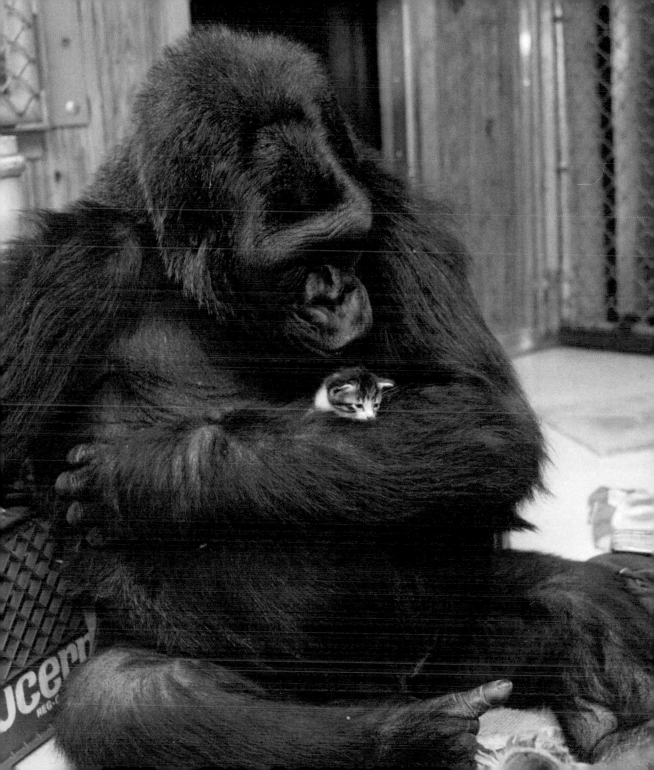

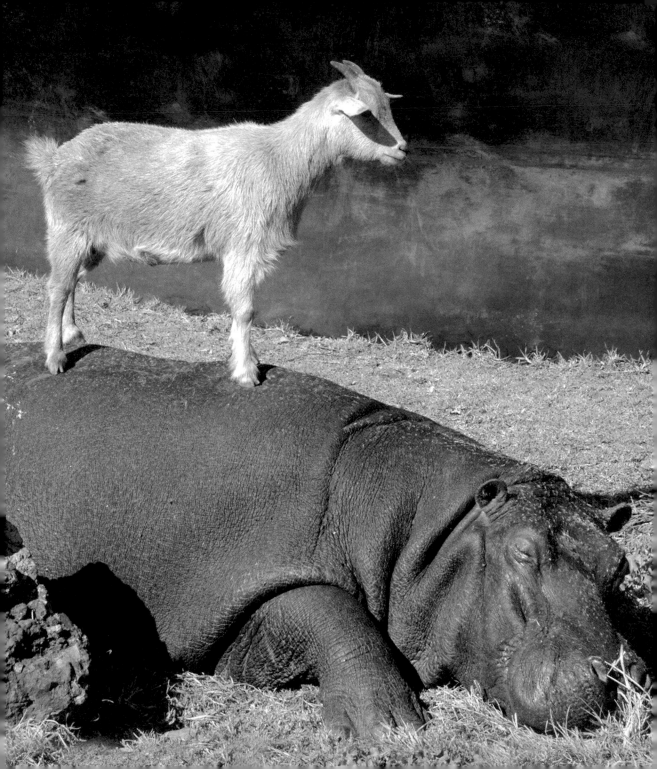

The Hippopotamus and the Pygmy Goat

HUMPHREY THE HIPPO ARRIVED AT THE RHINO AND LION NATURE Reserve at about six months of age. The reserve is best known for the animals listed in its name, especially the endangered rhinos that have been successfully bred there in the last decade. But other species are also welcome on the grounds—as was the case with Humphrey.

According to Lorinda Hern, whose father Ed owns the South African facility, the hippo had been completely hand-reared. He'd lived inside a house with his human "family" and lounged around in their backyard pool until he grew too huge for domestic life. At that point the family tried to keep him outside, but Humphrey, spoiled by his days as a house pet, would have none

of it. He broke down doors to get back inside. Perhaps his fervor shouldn't have been surprising. A hippo isn't the kind of animal to sit quietly and take whatever comes—unless it is relaxed and wallowing in a cool river. Mostly, hippos aggressively guard their territory. And though they may seem slow and lumbering, they can run over 20 miles an hour. In Africa, many consider the hippopotamus to be the most dangerous of all wild creatures, as they are said to kill more humans than any other large animal—including crocodiles and lions.

HIPPOPOTAMUS

KINGDOM: Animalia
PHYLUM: Chordata
CLASS: Mammalia
ORDER: Artiodactyla
FAMILY: Hippopotamidae
GENUS: *Hippopotamus*
SPECIES:
Hippopotamus amphibius

Fortunately, in the case of the human-friendly Humphrey, there was never any fear of an intentional attack. It was just the unintentional "collateral damage" of keeping a 4-ton hippo in a house that finally pushed his owners over the edge, which is how Humphrey ended up on the reserve.

Once he was there, the staff decided to introduce Humphrey to a "friend" right away to keep him from getting lonely and possibly acting out his frustrations again.

Enter one Cameroon mountain goat (also called a pygmy goat). The two seemed unconcerned by differences in size and species, and each found a friend in the

CAMEROON MOUNTAIN GOAT (PYGMY GOAT)

KINGDOM: Animalia
PHYLUM: Chordata
CLASS: Mammalia
ORDER: Artiodactyla
FAMILY: Bovidae
GENUS: *Capra*
SPECIES:
Capra aegagrus hircus

other. The goat proved to be a somewhat unfortunate role model, however. Cameroon mountain goats are endlessly curious, excellent escape artists, and notorious climbers quite capable of scaling a fence or even getting onto the roof of a building to see what's there. And the hippo, already prone to poor behavior, seemed content to copy his bovid friend's antics. He'd happily climb the fences of his pen—as much as a hippopotamus can be said to "climb" anything—and he'd surprise terrified tourists into giving up the contents of their picnic baskets.

Despite the mischief, the friendship did provide much-needed company for the lone hippo. And here comes the even more unexpected finish: Just before Humphrey was transferred to a private reserve elsewhere, he was discovered to be . . . a she!

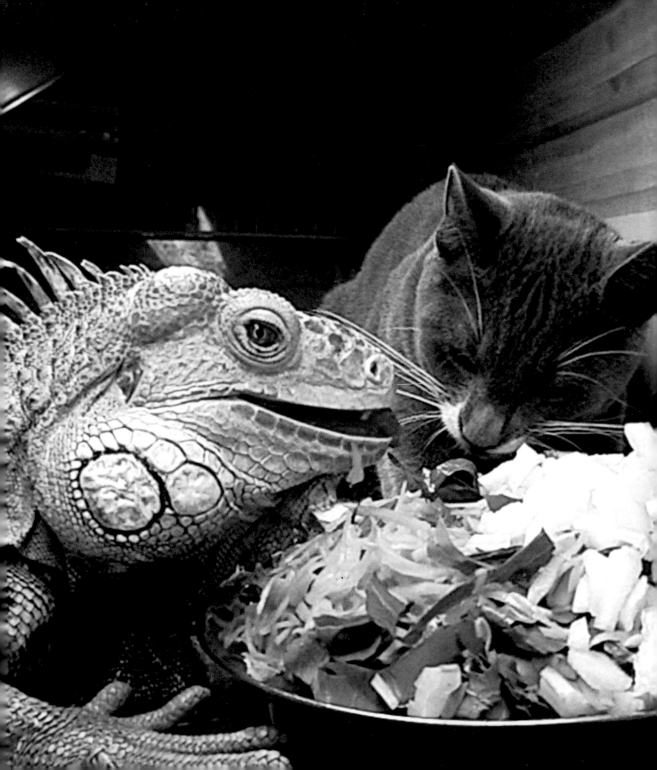

The Iguana and the House Cats

MANY PECULIAR THINGS CAN BE SEEN WANDERING the streets of New York City, but iguanas aren't typically among them. Yet one day, at Seventy-First Street and Thirteenth Avenue in Brooklyn, an iguana ambled past a man who, after a double take, decided the animal just didn't belong. He snatched it up with plans to give it a home, but his wife was less than thrilled. "You're not bringing that *thing* in here," she declared. So he called a friend with a giant soft spot for animals.

Rina Deych is a registered nurse and often does volunteer work on animal welfare issues. Her apartment already a zoo, she took the foot-long iguana without question and quickly researched what he needed. She bought an enclosure, humidifier, heaters, and

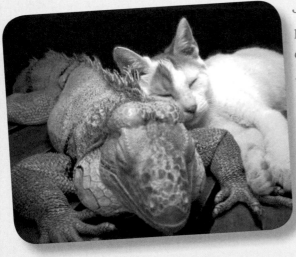

IGUANA

KINGDOM: Animalia
PHYLUM: Chordata
CLASS: Reptilia
ORDER: Squamata
FAMILY: Iguanidae
GENUS: Iguana
SPECIES: I. iguana

special bulbs that mimic sunlight. "I was pleased that at least he was vegetarian," says Rina, a vegan with a fridge well stocked with leafy greens, yellow veggies, and fruits. "Of course, I would have welcomed him, regardless." She named him Sobe.

The reptile thrived under her care, soon stretching to four and a half feet, nose to tail tip. Meanwhile, another needy critter found his way to Rina's door. "The kitten was near death when I found him," she says. "It's as if he knew, or the mother cat who dropped him there knew, that this was a sanctuary for animals." Even though the tiny feline had pneumonia, eye infections, and nasty infestations of fleas and worms, Rina felt she could save him and refused her vet's offer to euthanize him.

Indeed, Johann the cat soon improved markedly, and Rina decided to see how the two castoffs would get along. "When I put Jo into the iguana's enclosure, Sobe puffed up like Godzilla and hissed. He can look very big and threatening. But Jo didn't know to be afraid, so he just rubbed up against Sobe's rough skin and purred. Sobe probably wondered, What the heck? Why isn't he scared?" But the iguana calmed down quickly. He closed his eyes and let the kitten rub against his face and play with his

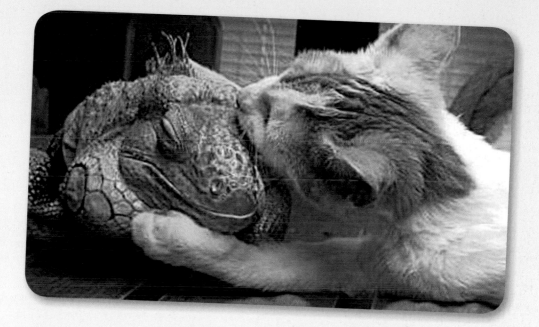

tail. He did nothing to discourage the contact, and even seemed to relish it.

Nowadays, Sobe is a free-range iguana in Rina's home. He'll get up on the bed with Jo and Rina's other cats and let them curl up around him, and he doesn't mind when they attempt to groom him or join him on his warm perch in his reptile enclosure. In fact, if the perch is empty, he'll wander around looking for the felines.

Although iguanas can be aggressive, especially once they are sexually mature, "Jo and the other cats have learned to read those cues and get out of the way when Sobe gets 'too affectionate,'" Rina says. Even the best of friends have their limits, after all.

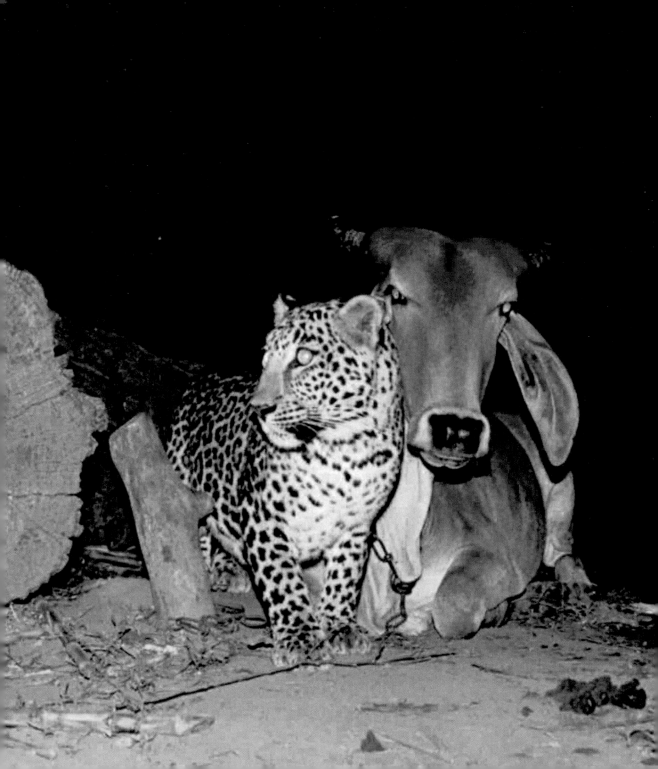

The Leopard

and the Cow

FROM THE BANKS OF INDIA'S DHADHAR RIVER, AND A village called Antoli, comes the story of the domestic cow and the wild leopard that sought its affection.

The leopard crept through the sugar cane on an October night, seeming to search for something. She found a cow tied in a field, the way villagers keep their livestock in this dusty farming community. The cat didn't harm the cow, but villagers worried about its predatory instincts, since they, too, were sometimes in the fields at night. They asked the Forest Department to remove the leopard to a wildlife sanctuary nearby.

And so the trappers came, and soon found themselves observers of an unexpected interaction. Wildlife conservationist

Rohit Vyas of Gujarat State was involved in several attempts to capture the leopard. The cat returned to the area nightly, often many times a night, but not as a predator sniffing out a warm meal. Instead, she came to be embraced. She approached the cow tentatively, rubbed her head against the cow's head, then settled against her body. The cow would lick the cat, starting with her head and neck, cleaning whatever she could reach as the cat wriggled in apparent delight. If the cow was asleep when the leopard arrived, the visitor would gently awaken her with a nuzzle to the leg before lying down and pressing close. Other cattle stood nearby, but the leopard ignored them. The chosen cow seemed pleased to give the leopard her nightly bath. For almost two months the cat showed up around eight in the evening and cuddled with the cow until the first hint of sunrise—as if hiding their strange tryst from the glare of day.

When word of the animals' bond got out, villagers became less afraid of the leopard and no longer worried about its capture. They were also surprised to see improved crop yields. Apparently the big cat was preying on pigs, monkeys, and jackals that usually devoured as much as a third of the farmers' harvest.

The cat stayed away for several weeks. Then on the last night the animals were seen together, the leopard

visited nine times before wandering away from her friend for good. Rohit Vyas suggests that the leopard had been young and motherless when it first strayed into the village, using agricultural fields as a pathway from a distant forest. Perhaps a curious lick between cat and cow stirred the domestic animal's maternal instinct. The leopard sought the cow's warmth for a time, but once she reached adulthood, her need for motherly affection diminished. She moved on.

Even with such a plausible explanation, "This relationship was unimaginable," says Rohit. "We were all spellbound by it. Who would expect a carnivore and hunter like a leopard to show love and affection toward its prey?"

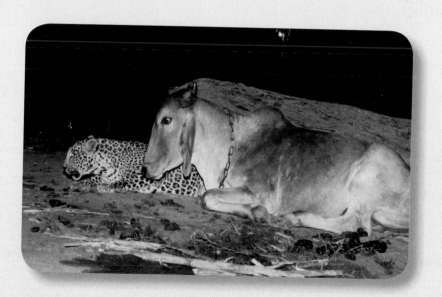

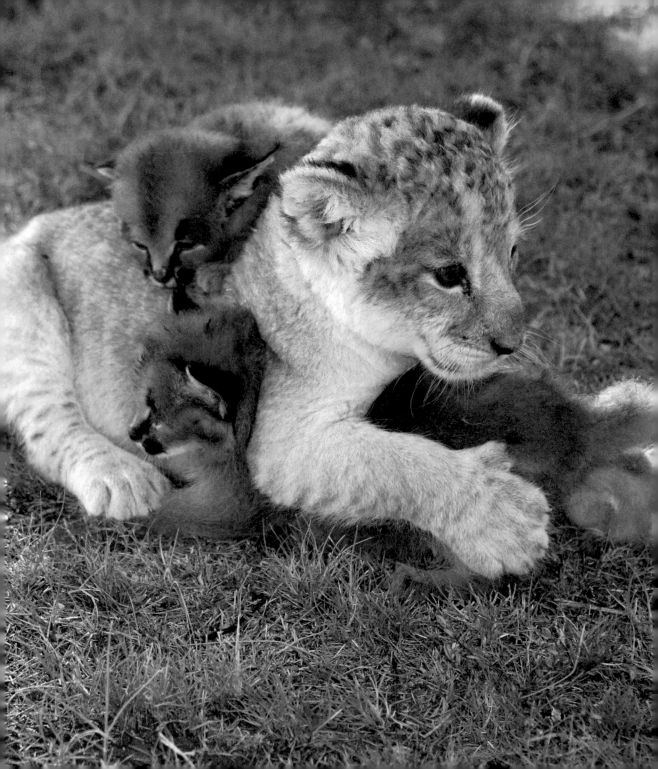

The Lion Cub and the Caracal Siblings

MISFORTUNE FOR A HANDFUL OF WILD CATS LED TO A HAPPY mingling of species at a South African reserve.

It happened at the Pumba Private Game Reserve in Port Elizabeth, a place where lions stalk and cheetahs race, where zebras and giraffes form stoic silhouettes on the dusty plains, and where rhinos and elephants turn watering holes into muddy plunge pools.

First, a lion cub named Sheba was brought to Pumba for rehabilitation. Sheba's mother, while still heavily pregnant, had been mistakenly caught by a game relocation team. Two of her cubs died shortly after birth, and she abandoned the third—most likely as a result of the stress of the capture.

CARACAL

KINGDOM: Animalia
PHYLUM: Chordata
CLASS: Mammalia
ORDER: Carnivora
FAMILY: Felidae
GENUS: Caracal
SPECIES: C. caracal

Staff at the Pumba Reserve took in the abandoned lion cub and did their best to fill the maternal void. They planned to raise her for eighteen months, then introduce her to a pride of lions on the nearly 7,000-hectare stretch of woodland and open plains.

Not too long after that, a pair of young caracal were brought to the reserve. Caracal are a smallish, quick-footed, lynxlike species that roams the open country of Africa and the Middle East. The caracal siblings had lost their mother to hunting dogs on a nearby farm after she had attacked the resident farmer's sheep. Normally, caracal kittens stick with their mothers for as much as a year, so without a stand-in parent the babies' future was grim. As they had with the lion cub, the staff at the Pumba Reserve did their best to mother the caracals. They named the brother–sister duo Jack and Jill. And they had a playmate for the kittens in mind—Sheba, the little, lonely lion cub.

Sheba, Jack, and Jill formed an instant bond. "They all live together in our farm house with our dog Frankie," says reserve director Dale Howarth, whose home sits on the boundary of the wildland. "They play together like any domestic cats, but obviously they are a

LION

KINGDOM: Animalia
PHYLUM: Chordata
CLASS: Mammalia
ORDER: Carnivora
FAMILY: Felidae
GENUS: Panthera
SPECIES: Panthera leo

lot bigger and more boisterous—and do a lot of damage to our carpets and furniture. Climbing up curtains is no challenge at all."

The three cats sleep together in a furry heap in the bedroom Dale shares with his wife, allowing for the regular feedings the youngsters require. At about twelve months, he says, the caracals will be given free range of the reserve, while the lioness will begin to separate from the "family" at about eighteen months, when she's ready to find a mate. "At that point, all the cats will be free to come and go as they feel comfortable; there's no pressure on the animals to stay or leave," Dale says.

Until then, each day is a sweet medley of eating, sleeping on the veranda, tumbling, grappling, clawing, and startling their caretakers as they race with mad abandon through house and garden. Kittens will be kittens, after all. Until they grow into caracals and lions.

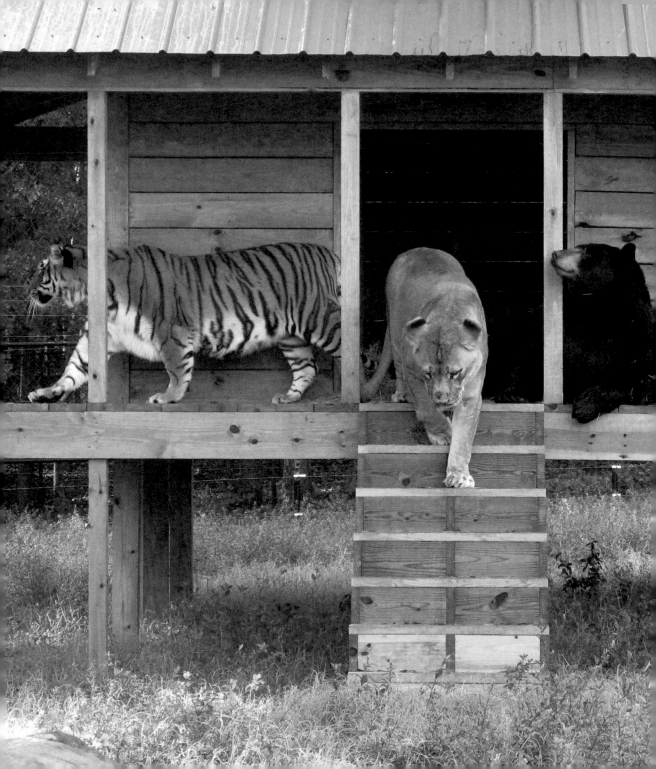

The Lion, the Tiger, and the Bear

OH, MY! IT'S THE BIG THREE THAT SPOOKED DOROTHY and her Oz companions, together again. But at Noah's Ark Animal Rehabilitation Center in Locust Grove, Georgia, lion, tiger, and bear aren't frightening; they're brothers.

They arrived together at the rehab center back in 2001, three cubs that had been confiscated by the Department of Natural Resources during a drug bust. They were Leo (the lion), Shere Khan (the tiger), and Baloo (the bear), and clearly the animals, not more than three months old apiece at the time, had become inseparable during their ordeal.

So together they remained. Their habitat at the center was made roomy enough for three, and they got a sturdy new "clubhouse,"

AMERICAN BLACK BEAR

KINGDOM: Animalia
PHYLUM: Chordata
CLASS: Mammalia
ORDER: Carnivora
FAMILY: Ursidae
GENUS: *Ursus*
SPECIES:
Ursus americanus

a wooden structure built as a place to bunk and, sometimes, to hide from the streams of awestruck visitors peering at the center's oddest mates. In the wild, these animals would have to cross oceans to meet face to face: lions come from Africa, tigers from Asia, and American black bears are, obviously, American. Yet their different beginnings haven't kept them from being contented roommates.

Jama Hedgecoth, one of the founders of Noah's Ark, says the animals play daily, sometimes roughly, yet tempers never flare. Everyone just gets along. Rubbing against each other, butting heads, and sleeping and eating together, "they truly live in harmony," she says. In the morning they awaken full of pep, ready to wrestle each other and attack their toys (tires, logs, and other relatively indestructible objects). As afternoon creeps in, the

TIGER

KINGDOM: Animalia
PHYLUM: Chordata
CLASS: Mammalia
ORDER: Carnivora
FAMILY: Felidae
GENUS: *Panthera*
SPECIES:
Panthera tigris

three become a pile of lazy bones, sprawled out in the yard or on the "porch" of their house as visitors wander by.

Unlike most housecats, tigers like water. So do bears. That means Shere Khan and Baloo can share another activity: getting wet. They've had a series of tubs to splash in over the years, and when their habitat is next renovated, they'll have access to a nearby creek.

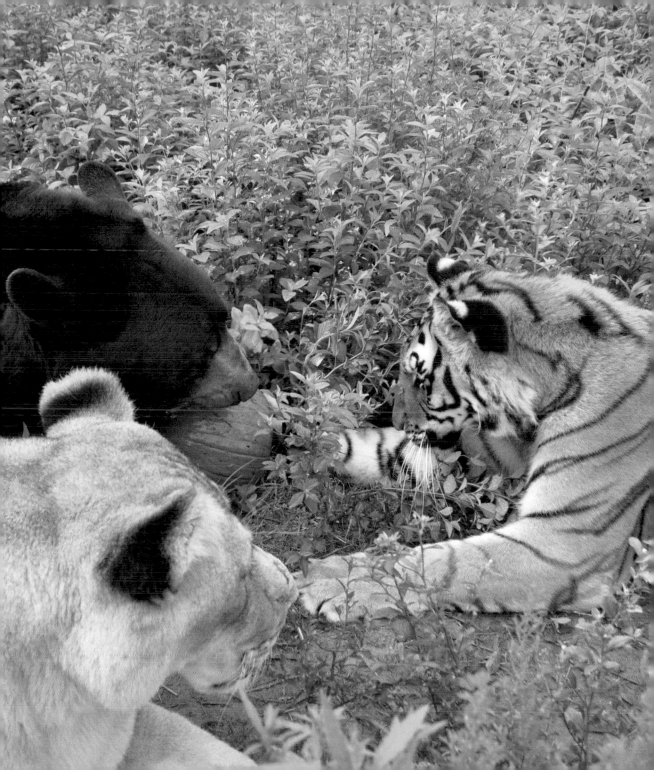

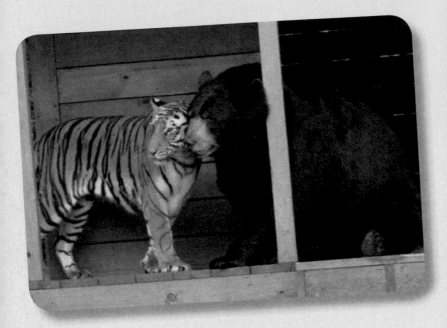

Though it was originally a series of unfortunate circumstances that brought them together in Georgia, U.S.A., the lion, tiger, and bear born continents apart have settled in as a family, unaware of their disparate genetics and far-flung origins. "This is their forever home now," says Jama, "and we hope they'll have a long and healthy life together."

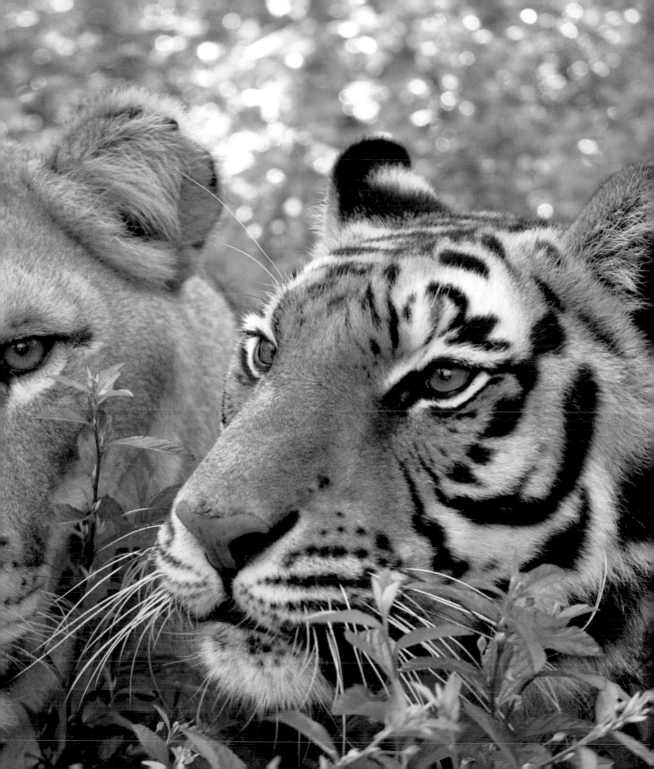

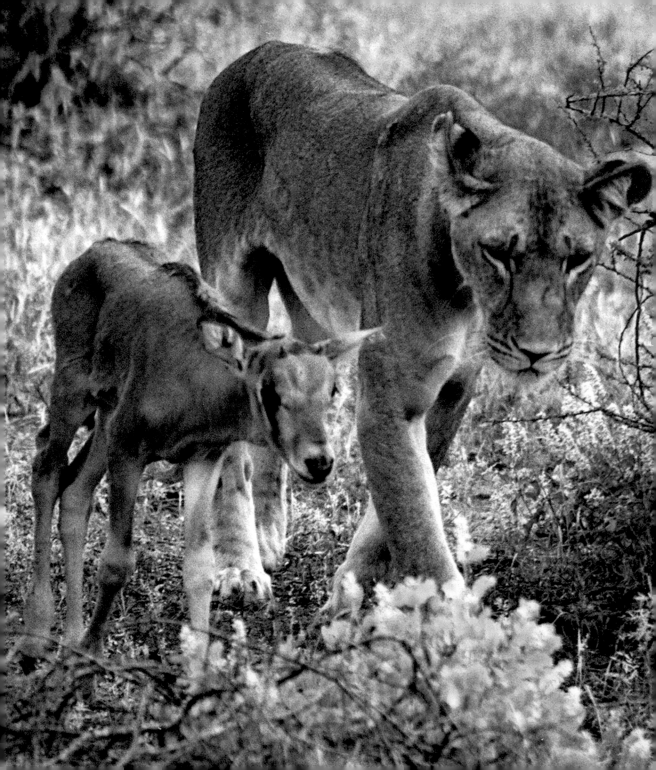

The Lioness and the Baby Oryx

IN THE SAMBURU NATIONAL RESERVE OF KENYA, THE East African bush unfolds in thick scrubland and grassy hills, with muddy rivers curling like ribbons through the plains. It is a land of hippos and elephants, of zebra and giraffe, where big cats and squawking monkeys drink from the same ephemeral watering holes and where nomadic herders bring cattle and goats to gnaw grasses from the dry earth. Here Nature veered from her customary course, and a legendary animal tale was born.

It was almost biblical: a lion and a baby antelope lying down together in peace. Local people said it was a message from God. They named the lion Kamunyak, meaning "blessed one." They came to the bush to bear witness to the strange pairing, and

hoped the wonderment would last.

Saba Douglas-Hamilton, a social anthropologist and conservationist for Save the Elephants, followed the animals for more than two weeks as their relationship grew. She watched as a normally fierce predator protected its prey. And she witnessed how it all ended.

The antelope was an oryx just finding its legs. The cat was a young lioness still pink-nosed with youth—too young to have given birth and lost cubs, but old enough to know her prey and to hunt and kill it. For some reason, this young lion, having become separated from her pride, adopted the oryx "as if it were her cub," says Saba. The two walked the land side by side and slept together, one an extension of the other.

For a time, the lioness seemed conflicted by two instincts—maternal and predatory. But her mothering won out, and she kept the oryx close at all times, licking it gently and treating it as her own young. And the oryx, apparently having not fully imprinted on its own kind and not aware that this was a predator at its side, wasn't fearful, and even tried to suckle from the big cat.

But a growing antelope needs rich, buttery antelope milk in its first few months, which no lion can provide. So the oryx limped toward starvation. The lion refused to leave the oryx long enough to hunt for herself. So she, too, was going hungry, becoming more lethargic with each passing day. As Saba spent time observing the pair, she sought explanations from lion experts

SAMBURU NATIONAL RESERVE
Situated alongside the Ewaso Nyiro River in Kenya, this wildlife reserve boasts an abundance of rare species, such as the Grevy's zebra, Somali ostrich, reticulated giraffe, gerenuk, and the East African oryx (the kind of oryx adopted by the lioness in this story).

around the world. But all were puzzled; no such pairing was known in the wild before. Though young lions will sometimes "play" with a captured animal for a time before eating it, this didn't seem a game. "Kamunyak and the calf are a living paradox. . . . Their intimacy defies the laws of nature," Saba said. And both would likely die as a result of it.

EAST AFRICAN ORYX

KINGDOM: Animalia
PHYLUM: Chordata
CLASS: Mammalia
ORDER: Artiodactyla
FAMILY: Bovidae
GENUS: Oryx
SPECIES: Oryx beisa

Locals wanted to help the animals, to try to feed them, to preserve the marvelous duo. An attempt to give meat to the lioness failed; she ignored the offering and went back to sleep. But the relationship would soon end. One hot day, with Kamunyak weak and resting in the grass, the oryx strayed out of sight, and a male lion snatched it up and carried it away. Kamunyak sprang up and followed but was helpless to assist. She sniffed the blood of "her baby" in the grass. She crouched down and watched the male devour it.

The next day, as if snapped out of her strange reverie, the lioness finally hunted again, eating her fill on a warthog and regaining her strength. But she didn't return to the normal life of a lion. Observers say in the coming months, Kamunyak adopted baby oryxes five more times—all for brief periods—before she herself disappeared from the area, adding to her mystery.

What lay behind this extraordinary scenario? Saba suggests the lion lost her pride at a critical time in her development. "Her trauma probably fueled her quirky obsession." Whatever stimulated the big cat's behavior, Kamunyak remains forever an enigma to behavioral scientists and a beautiful curiosity to the rest of us.

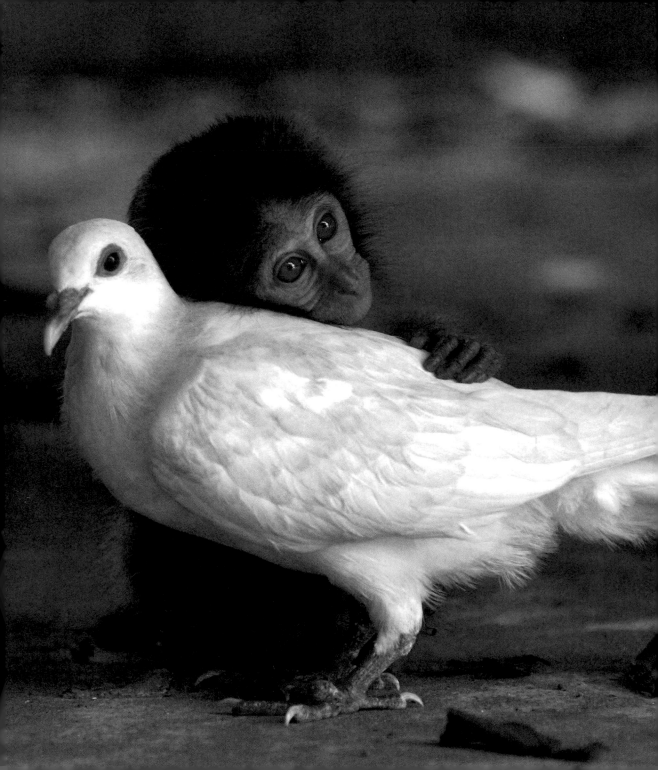

The Macaque and the Dove

OFF THE SOUTHERN COAST OF **C**HINA, ON AN ISLAND nestled in the Pearl River estuary of Guangdong Province, the rhesus monkey is king. Several hundred rhesus macaques, as they're also known, are legally protected, along with pangolins and pythons, in the Neilingding Island–Futian National Nature Reserve, a 2,000-acre wildlife haven lush with mangrove forest. It was there that one of those monkeys made an unexpected feathered friend.

According to Luo Hang, who heads the animal protection station on the mountainous isle, one day in September 2007, a white dove landed on the ground near the station, and lingered. It seemed to have lost its mate. White doves are often seen as

RHESUS MACAQUE

KINGDOM: Animalia
PHYLUM: Chordata
CLASS: Mammalia
ORDER: Primates
FAMILY: Cercopithecinae
GENUS: *Macaca*
SPECIES: *Macaca mulatta*

symbols of peace and long life, and Luo and his staff welcomed the animal into their midst. They adopted the bird, which they thought was about three years old, feeding it corn kernels and keeping it in an iron cage at the station. The bird had a metal band around its leg, so Luo assumed it was part of a bird migration study and should be released at the change of seasons.

While patroling the island—which is famous not only for its nature park but for having greeted the first known European-flagged boat to China in 1513—one of the reserve staff came across a baby macaque. It was alone, distressed, and very weak. Not more than three months old, it was far too young to survive on its own in the forest and extremely vulnerable to pythons and other predators. The reserve staff took the little animal, wide-eyed and clingy, back to the station, where it quickly met and hit it off with the feathered visitor already in residence.

For two months, the macaque and the dove shared a space and delighted the staff and visitors. They snacked on corn. The monkey turned pieces over in his little hands as he nibbled; the bird pecked on fallen bits behind him. The monkey chattered; the dove cooed. And at night they slept in the cage together, each the other's

WHITE RINGNECK DOVE

KINGDOM: Animalia
PHYLUM: Chordata
CLASS: Aves
ORDER: Columbiformes
FAMILY: Columbidae
GENUS: *Streptopelia*
SPECIES: *Streptopelia risoria*

pillow and blanket. Luo Hang says, "The monkey was sometimes naughty and seemed to make fun of the dove," but he showed affection, too. "If only the dove had hands to hug him back." It was a joyful scene, and people came from everywhere to see the way the odd couple lived together and looked after each other.

But the staff knew both animals would be better off in the wild, and so they prepared to set them free. The dove was released first, and off it flew. Luo then returned to the place where the macaque was first found, and he was pleased to find the monkey's family once again in its territory. The baby rejoined the troop without a hitch. With both monkey and bird back in their natural environments, one can only wonder if they will cross paths in the future. If they do, will there be a gesture of recognition?

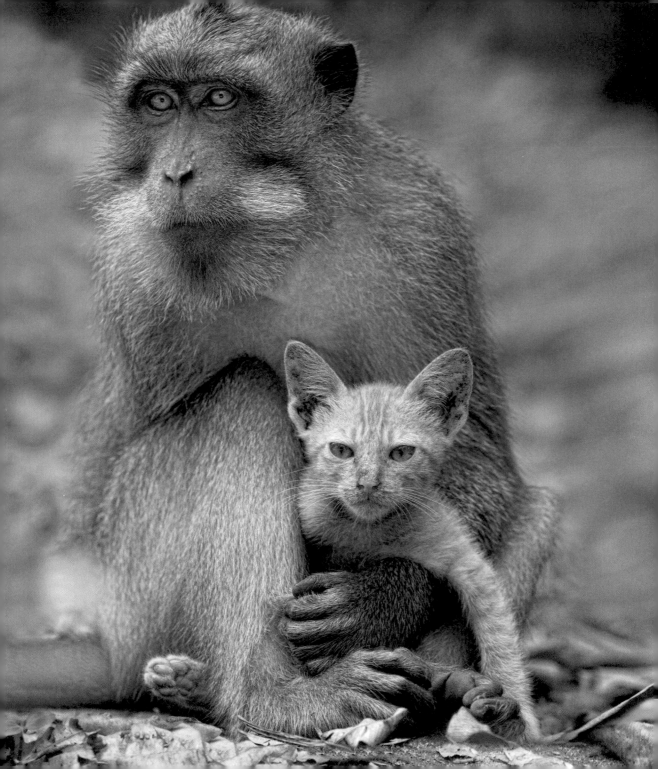

The Macaque and the Kitten

THERE IS A SACRED FOREST IN THE TOWN OF UBUD, ON the Indonesian island of Bali, where monkeys roam freely over the stones of a Hindu temple built centuries ago. The primates are long-tailed macaques, and many local villagers believe they guard the religious site against evil spirits.

One macaque recently brought its protective instinct to a more secular task—safeguarding a scrappy kitten that had strayed into arm's reach.

With more than 300 macaques in four separate troops (territorial groups) living in a relatively small area, it's not surprising that they occasionally meet other animals pawing across the temple grounds. But to form a bond like the one that this particular

macaque formed with this particular kitten seemed extraordinary to the people who witnessed it. Anne Young, who was on vacation and visiting the Sacred Monkey Forest during the time, was one of these witnesses.

"The pair had been together a few days, and whenever the park staff tried to capture the kitten, it would just run back to the monkey," Anne says. The macaque, a young male, would groom his feline friend, hug and nuzzle it, and even lay his head on the kitten's head as if it were a pillow. Although this species of monkey is quite social—and often lives without fear in close contact with people—this one wanted to keep his pet kitty to himself. He became wary of all the primates around him, and if other macaques or people got too close, he would try to hide his prize—once even using a bit of leaf to cover it—or climb higher or move deeper into the forest with the kitten in his arms.

The kitten, meanwhile, had plenty of opportunities to escape the macaque's clutches, "but it made no attempt whatsoever," Anne says. It seemed content to be carried around in the bigger animal's embrace.

Long-tailed macaques live in a strict social hierarchy in which males must prove

THE UBUD SACRED MONKEY FOREST

A popular tourist attraction in Bali, the Sacred Monkey Forest contains at least 115 different species of trees that provide home and shelter to over 300 macaques.

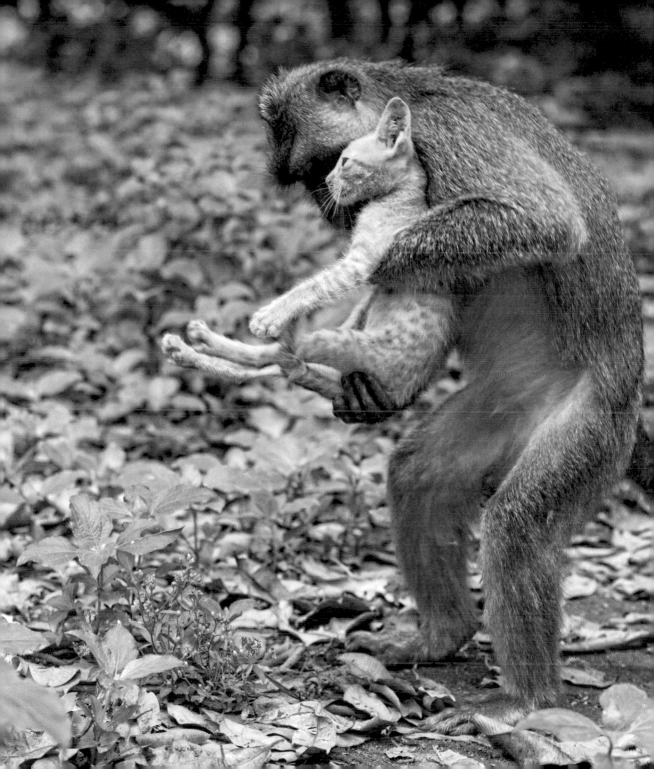

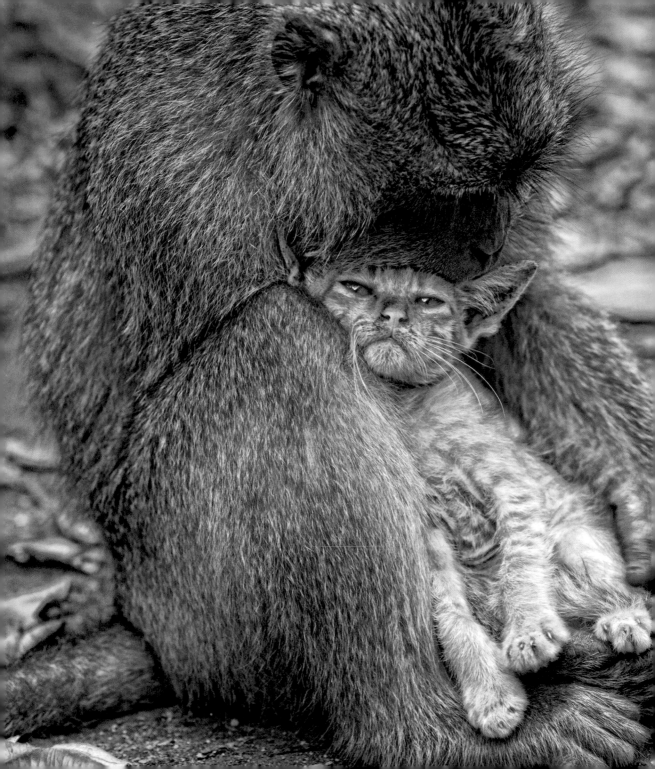

themselves worthy of female attention, and this troop was no exception. The kitten-petting male was not an "alpha male," or leader, among his own kind, and was probably not getting a lot of affection from the other macaques. And he certainly wasn't getting much affection from humans, either, as macaques have become something of a nuisance in Ubud, where they wander into rice fields or villages outside of the Forest boundaries and wreak havoc on private property.

The kitten appeared to be traveling solo as well, and may also have been craving some attention and companionship. Fortunately for both unmated primate and homeless feline, they found what they needed in each other among the temple ruins in Ubud.

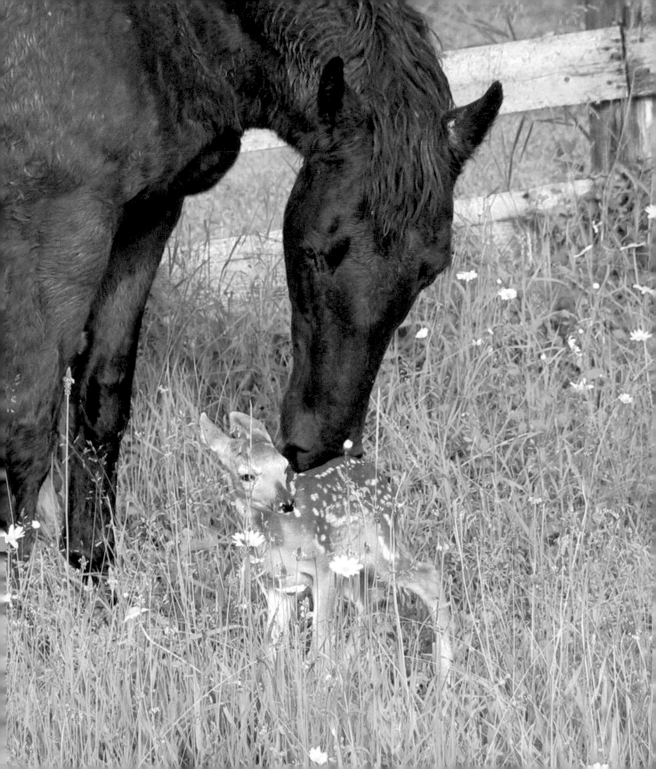

The Mare and the Fawn

BONNIE, A MORGAN QUARTER HORSE, WAS JUST TEN MONTHS old when she first came to live with the Muth family on their farm in Montana. She was adored by all, but especially by twelve-year-old Denise, an animal lover who immediately befriended Bonnie and spent six happy years closely bonded to the animal.

On a snowy morning after she'd turned eighteen, Denise was killed in a tragic car accident, leaving her parents heartbroken. Bob Muth says that as Denise's best friend and a beloved family member, Bonnie became the living link to their daughter.

As the horse grew older, her already gentle temperament mellowed into something even sweeter. "She was the most affectionate horse I'd ever known," Bob says. "She would have come into our

house if she could have found a way to negotiate the front steps."

So perhaps her actions one spring day, while extraordinary, aren't all that surprising.

Coyotes had set up a den at the edge of a field on the Muth farm, and that year the mated pair raised a single pup. An abundant supply of ground squirrels kept the animals well fed through the season. During the first week of June, Bob happened to be looking out the kitchen window and noticed a white-tailed deer giving birth in the barnyard.

The coyotes also noticed. And it quickly became clear that they were intent on getting the fawn away from its mother. "One coyote tried to distract the doe and get it to chase her while her pup was circling around from behind," wrote Bob after the incident. "I ran out to 'interfere' with nature," but before he could do anything, Bonnie stepped in. Bob watched in awe as the horse got between the coyotes and the fawn, then positioned herself over the fawn to protect it. And to his relief, with Bonnie towering over the tiny animal, the coyotes gave up and moved on. "She didn't even have to chase them off. They knew they had no chance," he says.

When the danger passed, Bonnie nickered softly and leaned down to lick the newborn as if she herself had just dropped a foal, nudging the baby into a standing position. "The fawn actually tried to nurse from Bonnie and seemed a bit frustrated that the horse was too tall to reach," Bob recalls.

WHITE-TAILED DEER

KINGDOM: Animalia
PHYLUM: Chordata
CLASS: Mammalia
ORDER: Artiodactyla
FAMILY: Cervidae
GENUS: Odocoileus
SPECIES: Odocoileus virginianus

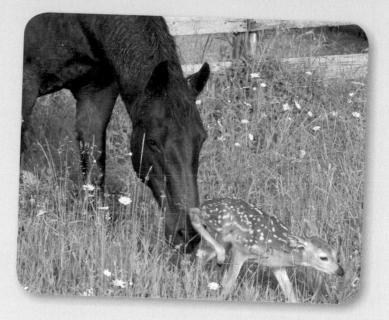

The encounter lasted about twenty minutes. The doe, breath-
ing heavily in exhaustion from the birth, had watched from a few
feet away. Now recovered and able to stand, she huffed in a signal
to her fawn and moved toward the fence, glancing back to make
sure her baby was following. The doe jumped over the fence and
the fawn squeezed beneath it, and off they went.
"Bonnie leaned over the top rail, watching and whin-
nying," Bob says.

Bob was heartened by his mare's nurturing
and compassionate behavior, though he expected
nothing less of the sweet animal that brought his
family so much joy and connected them to the
daughter they had lost.

MORGAN QUARTER
HORSE

KINGDOM: Animalia
PHYLUM: Chordata
CLASS: Mammalia
ORDER: Perissodactyla
FAMILY: Equidae
GENUS: Equus
SPECIES: Equus ferus
caballus

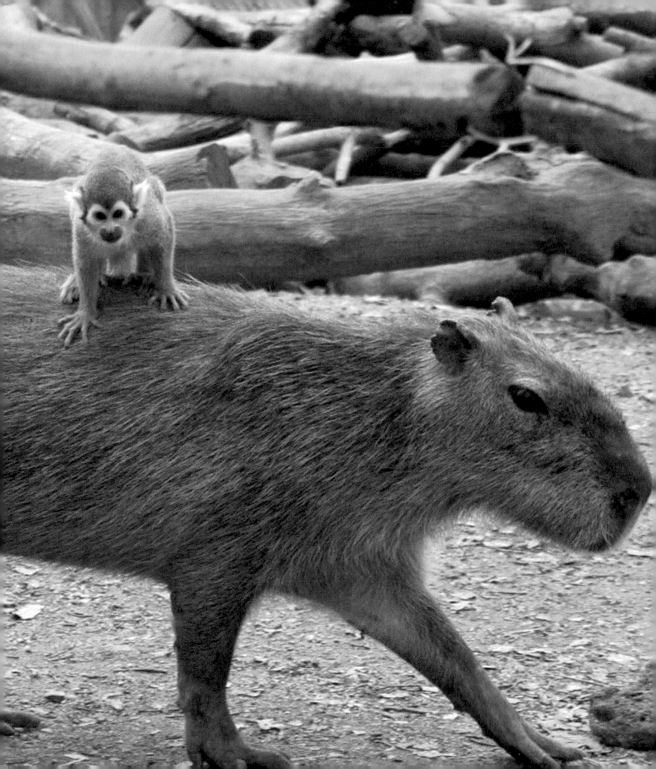

The Monkeys and the Capybaras

ONE'S UP, ONE'S DOWN. THE AGILE SQUIRREL MONKEY LEAPS from tree to tree above; the capybara, South America's largest rodent (a sort of oversize guinea pig), moves through the grasses or wallows in a stream below. Zoos in different parts of the world have found this pair of animals can get along quite well, even when they meet in the middle.

In some of South America's wildest places, the animals share a habitat—densely forested areas near bodies of water. So it might not be totally unnatural for them to come face to face in nature. Conveniently for a zoo setting, there's no competition for space. Each fills a different niche. Remember: one up, one down. But in close quarters, some strange things happen.

While no one trekking through the Amazon River Basin has ever reported monkeys riding capybaras or chasing them and grabbing at their feet, that's what goes on at the Tobu Zoo near Tokyo, Japan. The monkeys have even been said to use the rodents as step stools to reach the trees, to take naps on their backs, and to "kiss" the rodents on their giant heads.

SQUIRREL MONKEY

KINGDOM: Animalia
PHYLUM: Chordata
CLASS: Mammalia
ORDER: Primates
FAMILY: Cebidae
GENUS: Saimiri
SPECIES: Simia sciureus

"Sometimes a squirrel monkey will pry open a capybara's mouth as if to say, 'What are you eating?'" says head zookeeper Yasuhiro Shimo. "Capybaras are gentle animals and seem mostly disinterested. The monkeys, on the other hand, are very physical and act playfully." Only occasionally "the capybara might get annoyed and shake himself to get the monkey off his back."

Though their energy levels suggest that they are complete opposites, with the monkey frantic and fast—leaping more than six feet between skinny branches—and the capybara slow and steady, these species actually share some key traits. Both are social types who live in groups of up to one hundred of their own kind. Both have a taste for fruit (though the monkeys munch insects as well), and both are quite vocal—monkeys "chucking"

CAPYBARA

KINGDOM: Animalia
PHYLUM: Chordata
CLASS: Mammalia
ORDER: Rodentia
FAMILY: Hydrochaeridae
GENUS: Hydrochoerus
SPECIES: Hydrochoerus hydrochaeris

to their young or mates and shrieking if under threat, and the rodents purring, barking, squealing, and grunting as the situation demands.

Yet, despite some similarities, mixing these species doesn't always go smoothly. Another Japanese zoo that combines the two had an incident years ago when a monkey startled a capybara, and the rodent unfortunately struck out defensively, killing the monkey with a bite to the neck. However, zoo managers believe it was a onetime thing, as they hadn't seen aggression between the animals before or since. Mostly, everyone gets along fine.

And at Tobu, the monkey–rodent exhibit is a visitor favorite. "Watching the interactions between the mellow capybara and the impish squirrel monkey, it is hard not to smile," the keeper says. "Viewers especially love the 'capybara taxi' taking the monkey for a ride."

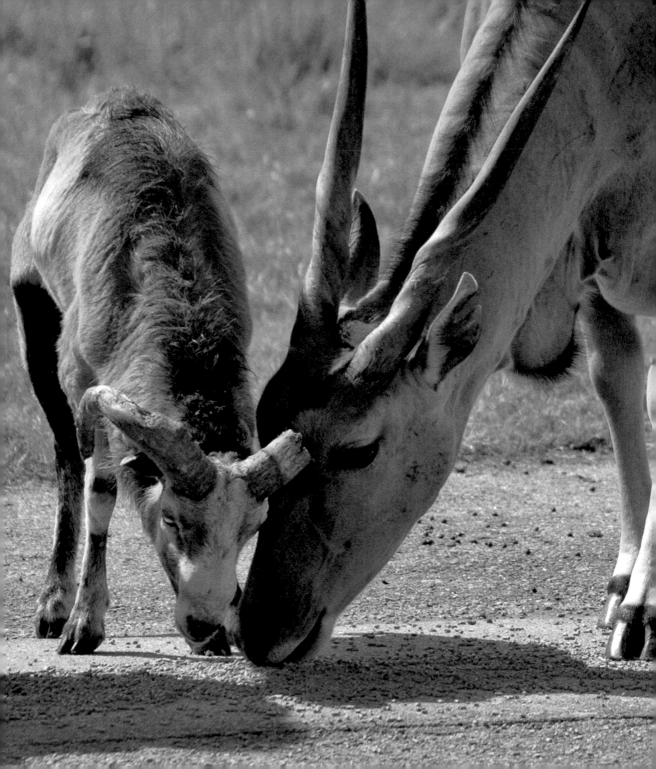

The Mouflon *and the* Eland

UNLESS YOU'RE UP ON YOUR UNGULATES, WHICH MOST of us aren't, you might not know exactly what a mouflon is. It sounds like a hairdo. And an eland? Anyone?

Turns out a mouflon is the smallest of the wild horned sheep. It hides away in steep mountainous woodlands in places like Iraq and Iran. The mammal was introduced to various Mediterranean islands and to continental Europe long ago, and more recently to ranches in the United States for hunting.

Then there's the eland, an antelope that hoofs across Africa's open plains. The plant-eater hangs out with sometimes hundreds of its buddies, though it doesn't seem to establish close ties in the wild and often leaves one herd for another.

But when a male mouflon met a female eland more than fifteen years ago at the Lion Country Safari Park in Palm Beach County, Florida, a close tie was inevitable. It was the beginning of an ongoing boy-meets-girl love story, says the park's wildlife director Terry Wolf, "that is, if you believe animals can love and not just lust!"

ELAND

KINGDOM: Animalia
PHYLUM: Chordata
CLASS: Mammalia
ORDER: Artiodactyla
FAMILY: Bovidae
GENUS: *Taurotragus*
SPECIES:
Taurotragus oryx

The mouflon is an old male that was a hoofed Casanova in his younger days, with many mates of his own kind. But living among the eland, what is a lonely male sheep to do?

"He follows this one female eland passionately!" Terry says. "When she stops to graze, he will gently paw at her rear leg with his front foot, as if trying to coax her to come down to his level. After all, he is quite a bit shorter than she." Then, when she lies down, the sheep acts the gentleman, lying quietly next to her.

Only the one eland has grabbed the sheep's attention; he never bothers with the other females. "People think that the affair is cute," Terry says, "but obviously it will go nowhere." And with the mouflon already beyond his expected lifespan of twenty years, he no longer keeps up with his girlfriend as he once did, making his advances even less effective.

MOUFLON

KINGDOM: Animalia
PHYLUM: Chordata
CLASS: Mammalia
ORDER: Artiodactyla
FAMILY: Bovidae
GENUS: *Ovis*
SPECIES: *Ovis aries*

The eland, for her part, can be aloof—standing around chewing her cud, back turned to her suitor—but she seems content enough to be admired. "I think the mouflon is just happy she tolerates him," Terry says. "But most important to us, she keeps him mobile, which is why he's still around."

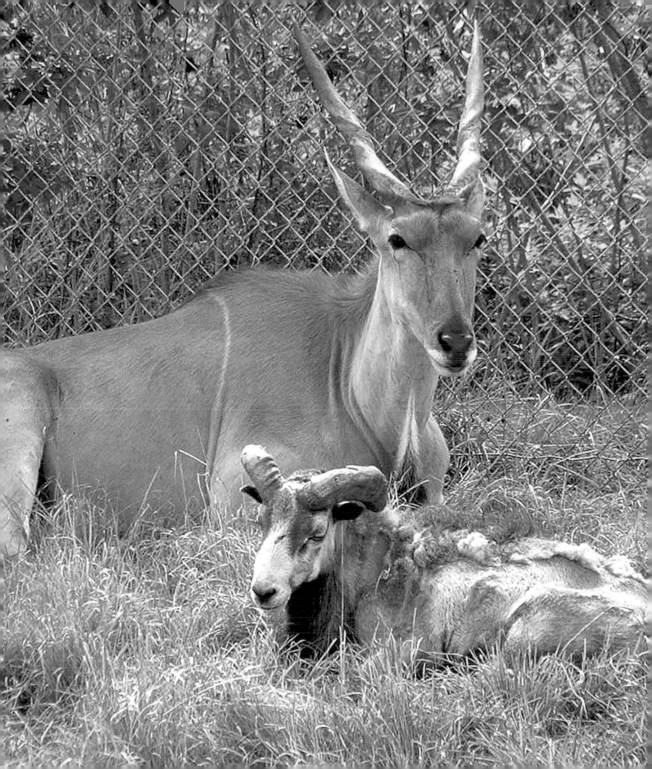

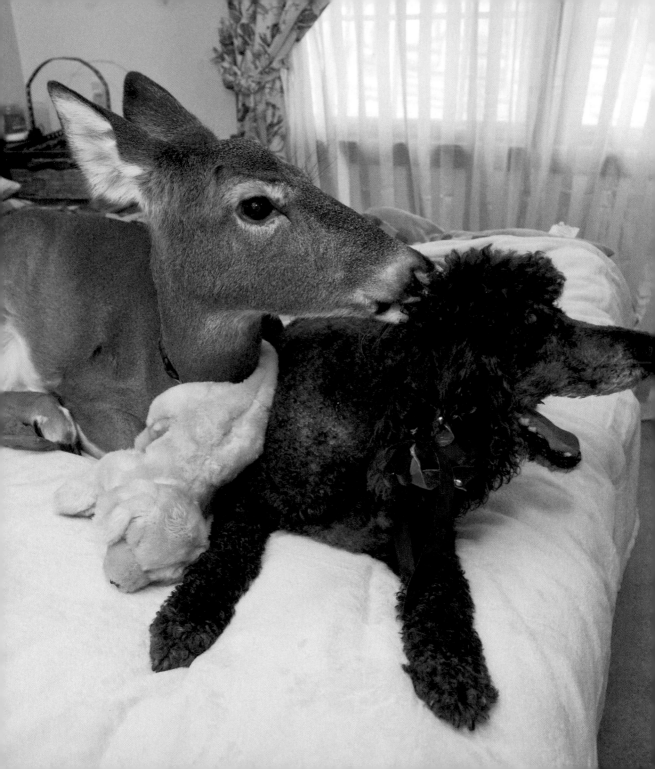

The Nearsighted Deer

and the Poodle

MEET DILLIE, THE COFFEE-DRINKING, BED-HOGGING, dog-loving "house deer" that has become an oversize member of veterinarian Melanie Butera's menagerie in suburban Ohio.

When the farm-bred white-tailed deer came to the Elm Ridge Animal Hospital in Canal Fulton, Ohio, she was a very sick little animal, unable to eat or stand up on her bony legs. She was also virtually blind from a birth defect. Melanie ultimately decided to care for the deer at home, a household already heavily populated with a husband, two children, poodle Lady, cats Spaz and Neffie, and bird Screamie, not to mention a barnyard's worth of animals outside.

With the exception of Screamie, who got a poor introduction to

Dillie when the deer grabbed her by the tail feathers and tossed her, everyone in the house has grown to love Dillie. The cats approve of her warmth when they curl up next to her, and are happy to let the deer groom them from head to tail. But Lady is Dillie's best friend. Says Melanie, "Lady was a great comfort to Dillie those first weeks, letting the scared little deer lie next to her on the couch or bed as she licked her down. Now, Dillie licks the poodle on the back or head, and sometimes nibbles her ears." At the nipping, "Lady might snarl a little and play-bite her," but the response does no harm. As a game, Lady likes to steal stuffed animals from Dillie and proudly carry them around, finally leaving them in the deer's path so she'll stumble across them later.

There's also a bit of dog–deer mischief to report. Despite Dillie's impaired vision, at Lady's bidding she'll grab bags of snacks from high shelves for the two to gobble down. Lady will try to steal food from Dillie, who boasts a surprisingly sophisticated palate that includes an appreciation for spaghetti, ice cream, coffee with a lot of milk, and, as a special treat, roses (which she crunches through like candy). And of course, as deer are wont to do, she happily destroys every plant in the Buteras' yard as Lady lazes about nearby.

For a time both Dillie and Lady tried to share their owner's bed at night. "I am a night owl," says Melanie,

"and would come to bed after everyone else was already positioned, and sometimes couldn't even find a spot." She also suffered the deer's hooves digging into her back. Luckily, the animals resolved the issue on their own. Feeling the squeeze, Lady found a spot on an extra bed in the room, and Dillie took over a guest room elsewhere in the house. Now, Lady often joins the deer in "her" room for a nap, even when all beds are open.

Interestingly, Dillie is afraid of other dogs, even tiny puppies. "She'll fluff up her tail and stomp her feet" if any canine but Lady gets too close, Melanie says. But that's never been the case with Lady. "Dillie grew up with Lady and sees her as family."

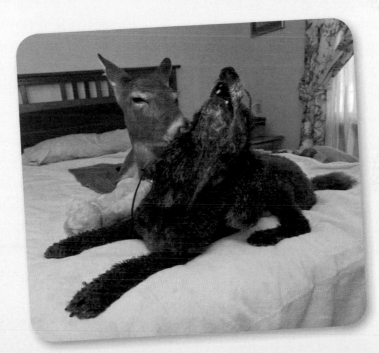

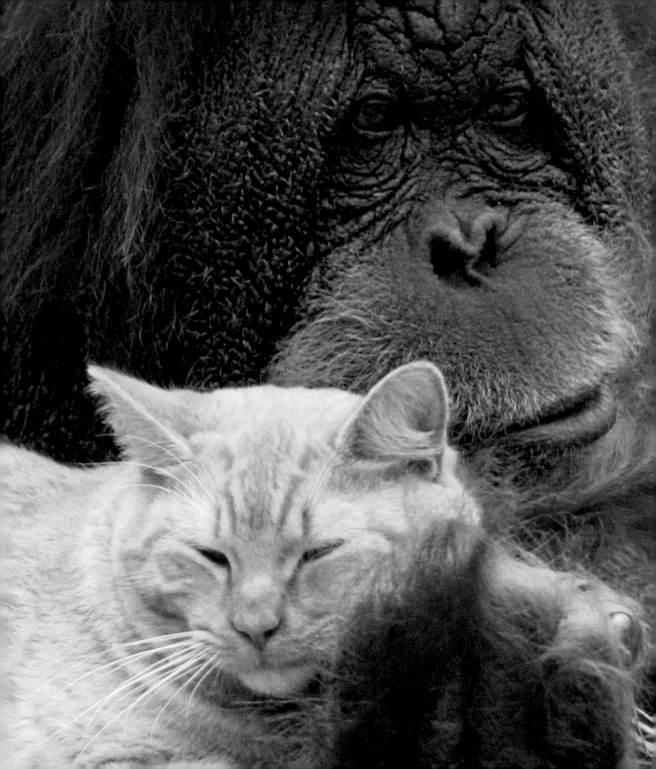

The Orangutan

and the Kitten

KOKO GOT ALL THE PRESS, BUT THE FAMOUS GORILLA isn't the only big ape to find solace in a cat. Consider Tonda, an orangutan who lived at ZooWorld in Panama City, Florida, for eleven years. She was never known for her sweet nature; beyond the occasional hand-holding or furtive smooch, even she and her mate weren't terribly affectionate. But when the male died, Tonda began to realize her loss and entered a slow decline in appetite and enthusiasm for life. The ZooWorld staff gave her plenty of activities to enrich her days, from playing with toys to painting canvasses, but her interest waned and she became sullen. With no new mate available for the old girl, keepers decided to find her a friend of another kind.

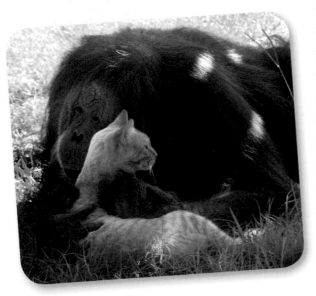

ORANGUTAN

KINGDOM: Animalia
PHYLUM: Chordata
CLASS: Mammalia
ORDER: Primates
FAMILY: Hominidae
GENUS: *Pongo*
SPECIES: *Pongo borneo*

A ginger feline that became known as T. K., or Tonda's Kitty, got a slow, safe introduction to the primate's world. "At first, we let them see each other but without contact, to watch how they'd react," recalls the zoo's director of education, Stephanie Willard. Then, contact was allowed for short stints to keep Tonda from getting too excited. With time, "she'd get angrier and angrier when we'd take him away," Willard says. "That was her kitty!" So eventually, "we went for the gusto and put them together for real. And once their relationship had time to build, they were inseparable."

T. K. became Tonda's everything. When they weren't in physical contact, she always had an eye on him. She'd tuck him under a blanket at naptime and shake a cornhusk for him to chase at playtime. And she'd scoop him up and carry him off to bed at night. T. K., meanwhile, "loved to love the primate" by rubbing against Tonda's legs, licking and chewing her hands and feet, and reveling in her endless attentiveness.

"You have to remember, this

114

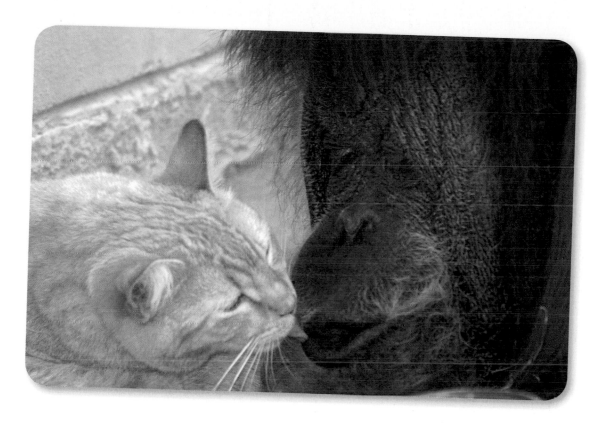

was not a docile orangutan that was easily handled," Willard says. Orangutans can be extremely dangerous, and Tonda had a lot of wildness in her. But her rough nature toward people and others didn't keep her from finding a friend in T. K. "Their kinship was 100 percent real, worked out on their own terms. Animals don't get enough credit for all they're capable of emotionally," Willard says. Most important, "this bond really meant something. It did something for Tonda both mentally and physically. It saved her life."

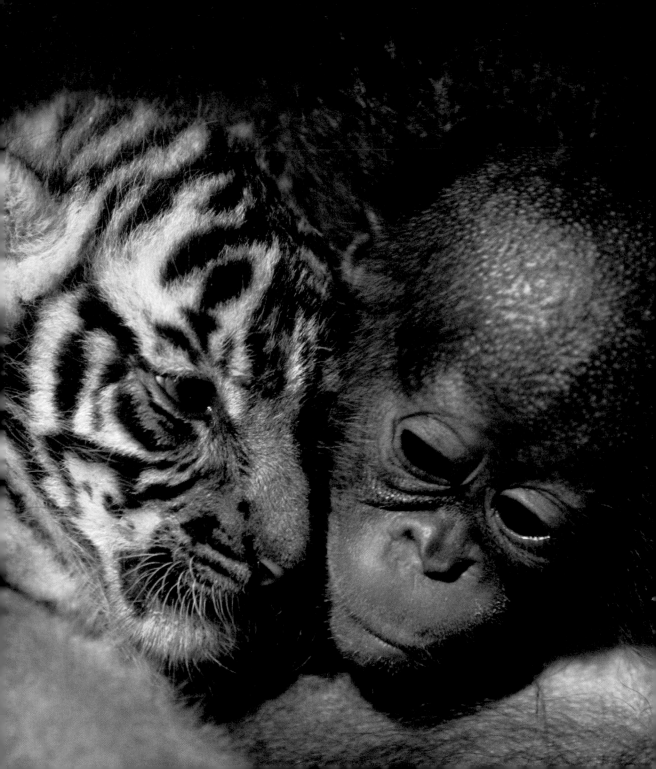

The Orangutan Babies and the Tiger Cubs

A MATCHUP OF CAPTIVE-BORN BABIES WAS THE TALK OF the Taman Safari Zoo in Cisarua, Indonesia. One-month-old Sumatran tiger twins and a pair of little orangutans just a few months older shared a room in the zoo's nursery. The parents of both primates and cats had proven unfit or uninterested in their young, so zoo staff decided to mother the whole bunch as one litter.

The orangutans, Nia and Irma, and the tigers, Dema and Manis, formed something like a nursery school romper room when they were brought together during the day. "As is common with baby animals, they'd run and play together," says animal curator Sharamy Prastiti. "Sometimes an orangutan would pounce on

the belly of a tiger. Other times a cub would bite an orangutan's ear. They loved to tease each other, like kids do." Naptime turned boisterous individuals into a furry pile of snoring babies. Cuddling, nuzzling—orangutans and kittens were content to be physically close as much as possible.

SUMATRAN TIGER

KINGDOM: Animalia
PHYLUM: Chordata
CLASS: Mammalia
ORDER: Carnivora
FAMILY: Felidae
GENUS: Panthera
SPECIES: Panthera tigris sumatrae

The zoo staff began giving the animals more time apart in their own exhibits as they grew, and planned to separate them completely when the cubs were five months old. "At that point, the tigers are much bigger than the orangutans, and can be very active and sometimes naughty and rough," says Sharamy.

When the youngsters were first parted, "they didn't want to be independent—they looked as if they were all missing something. They'd make unusual sounds, as if crying without tears," Sharamy says. But after a week or so, "they became adjusted to being on their own and the new situation." The former pals now have no contact at all, a separation that's appropriate and necessary to keep them safe. Though the orangutans are fruit-eaters, the tigers' natural instinct, of course, is to hunt and eat meat. Nursery school is over.

The shared childhood appears to have benefited all concerned, but these animals also share something that can't be celebrated: In the wild, both species are critically endangered.

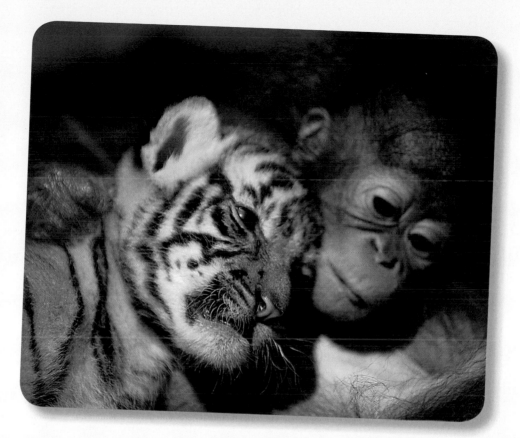

Sumatran tigers, a subspecies living naturally only on a single Indonesian island, may be down to about 500 animals. And orangutan populations are also declining. Both big cats and big apes compete with humans for habitat, a conservation problem without a simple solution.

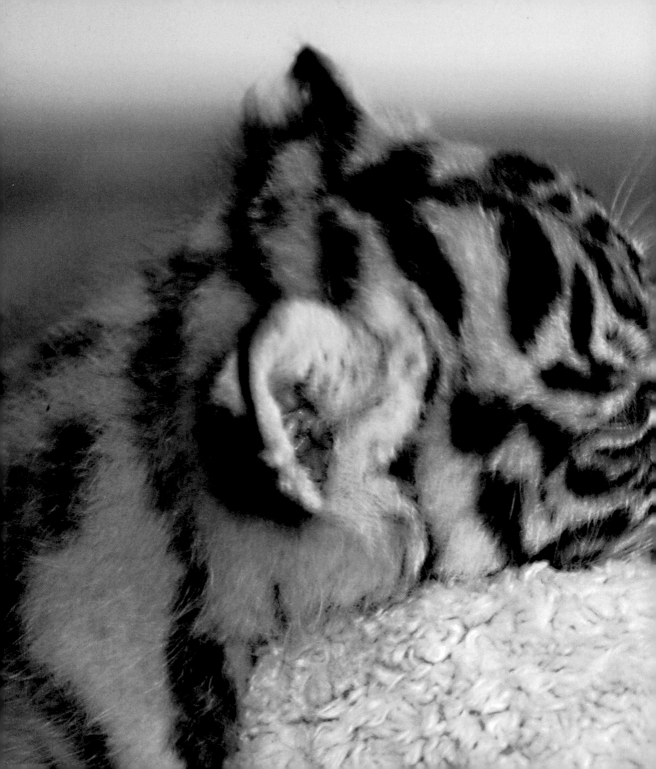

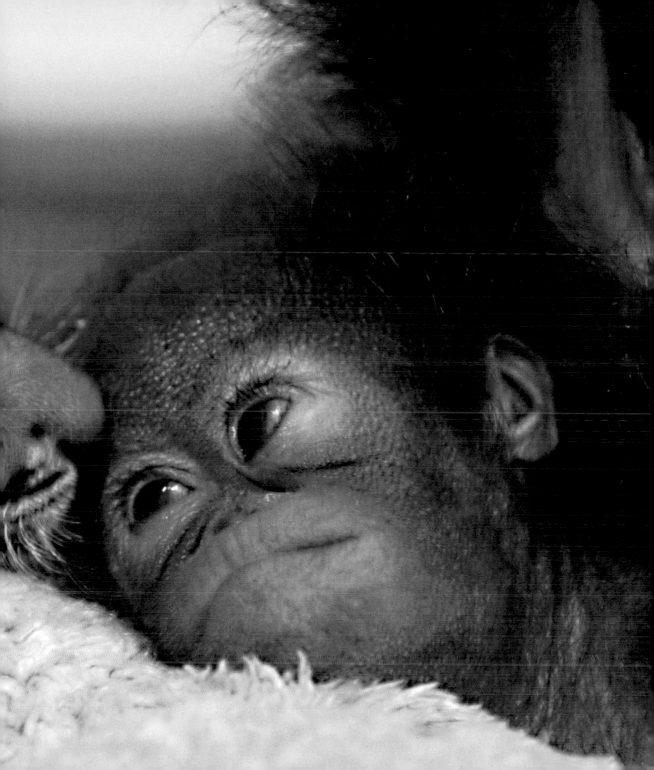

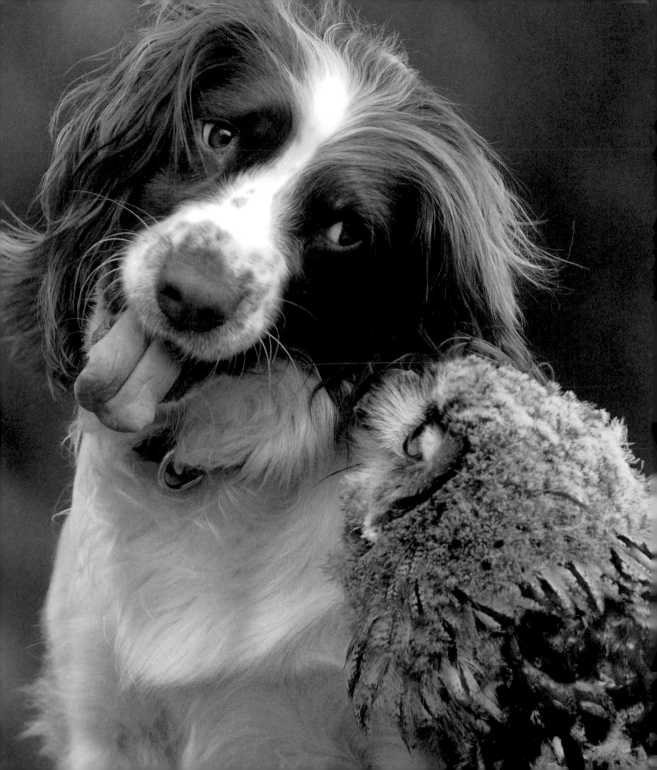

The Owl and the Spaniel

AT A BIRD-OF-PREY CONSERVATION CENTER IN LISKEARD, Cornwall, a spaniel named Sophi has a taste for owls. Fortunately, she licks, not bites. And the meeting of mouths is mutual.

English spaniels are natural hunters, and flushing out and retrieving birds is their specialty. But in this case, Sophi the dog seems to have replaced those hunting instincts with something a bit more genial.

Normally Sharon Bindon, the conservationist who runs the center, doesn't bring birds into her house. In fact, Sophi hadn't gotten to meet one close up until the day Bramble arrived. But the owlet showed up at just two weeks of age, still featherless and too young to be placed in the aviary. So Sharon made an

GREAT HORNED OWL

KINGDOM: Animalia
PHYLUM: Chordata
CLASS: Aves
ORDER: Strigiformes
FAMILY: Strigidae
GENUS: *Bubo*
SPECIES: *B. virginianus*

exception and carried the naked little creature inside.

"On that very first day, Sophi, then three, jumped up on the sofa to investigate the new arrival on my lap," says Sharon. "As her way of affection, she started licking Bramble's beak. From that day on, it became a daily ritual."

Bramble was given a cozy crate in the sitting room of the house. But whenever Sophi was close by, the bird would flap and dance around until she was let out to join the dog for a cleaning or cuddling session. "And if Sophi wasn't there, Bramble would go look for her," says Sharon. "The kissing-licking thing was a two-way street: Bramble would 'beak' Sophi in return for Sophi's kisses."

In the evening, sometimes bird and dog would spoon on the carpet and fall asleep. "Bramble wouldn't go back into her crate until we all went to bed."

Once Bramble was older and less fragile, she was introduced into the aviary so she could fly around. But Sharon says the owl swoops down regularly to spend time with Sophi, always in the mood for a mutual grooming, bird–dog style.

SPANIEL

Gentle, friendly—the
perfect family pet—
the English springer
spaniel was originally
a hunting dog, known
for its ability to flush,
or "spring" game.

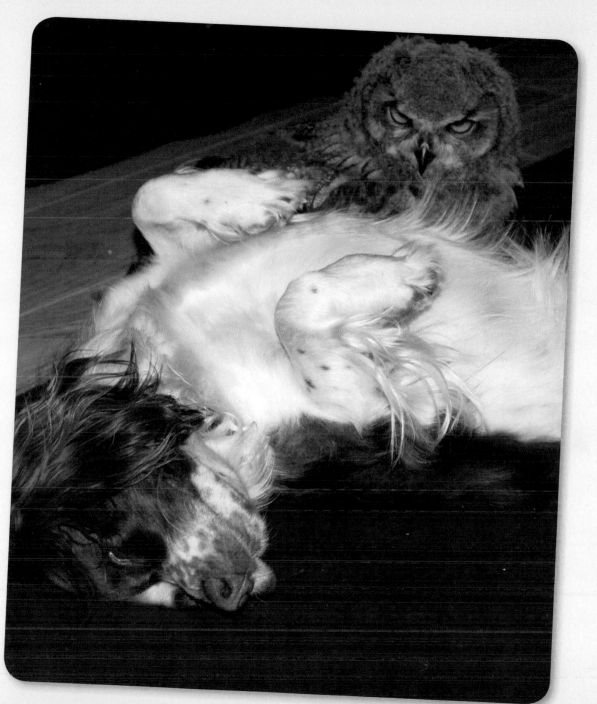

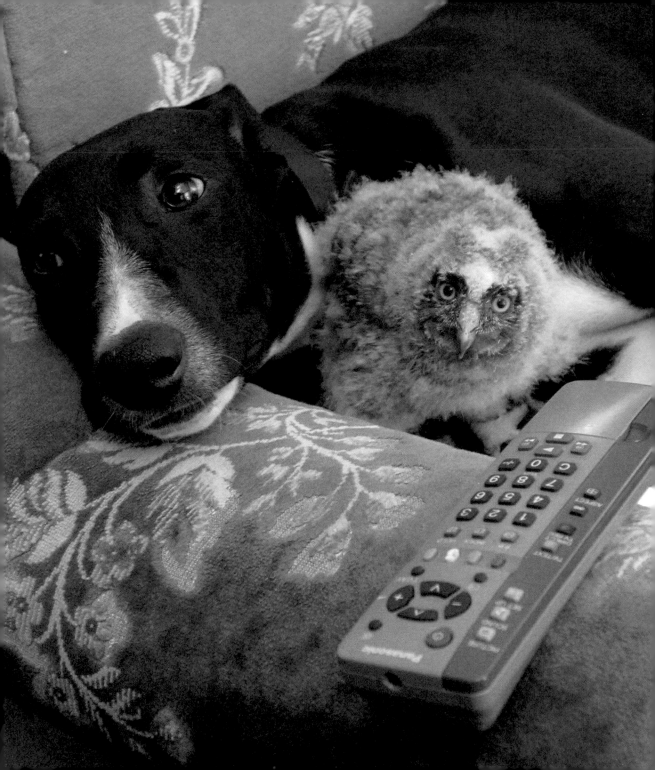

The Owlet *and* *the* Greyhound

WHAT STRANGE SCENARIO IS THIS? IT BEGINS NORMALLY enough, with a dog lounging on a sofa. But look again: There's an owl perched between his paws. Oh, and they're both watching TV.

That's Torque the greyhound and his little buddy Shrek, a baby female long-eared owl that the pup took under his paw soon after the bird hatched at the Ringwood Raptor Center in Hampshire's New Forest, in the United Kingdom.

When the owl first hatched, Torque became excited and wanted to sniff the new arrival. "I had taken Shrek the owlet out of the incubator, and then comes this big nose into my hand," recalls John Picton, head falconer and Torque's owner. "That was

followed by a big old tongue to say hello. It was quite funny."

In some bird species, a parent bird may kill one of its young to give the other a better chance at survival. To protect Shrek from infanticide, the owlet wasn't placed back with its mother after hatching. Instead, John took the tiny knot of feathers home to care for her there. As the chick became steadier on her feet, John let Torque and the little bird get better acquainted. First, he'd feed Shrek her meals of marsh rats and quail in the same room where Torque was eating, then he'd hold the bird out so Torque could get a look and a sniff. Torque would lick the bird, and the bird would give the dog a gentle peck on the nose. Eventually, "they were bounding through the house together, really enjoying each other." In a comical game, Shrek stood still until Torque wandered by and then pounced on him. The two cuddled on the couch, seeming entranced by *East Enders* and *Coronation Street*, among other favorite shows. They'd hang around outside like loving siblings, with Torque standing guard over the feathered youngster or following her as she toddled across the grass.

As Shrek's legs got stronger from roaming with Torque, she soon realized she had another set of limbs to stretch. And once she found her wings, Shrek began to explore a world where Torque couldn't follow. The

owl was placed in an aviary at the raptor center with other birds, and Torque continued his life on the ground, a little lonelier than before. But whenever Torque trotted past the birds' house, "there would be a very nice hoot from inside, Shrek to Torque," says John. It seemed dog and bird remained friends—even from afar.

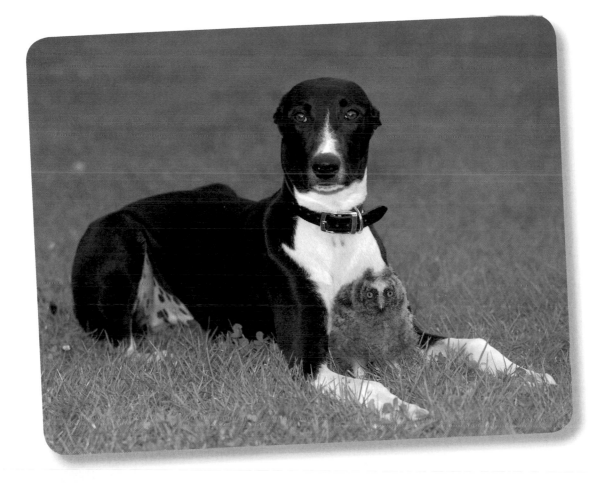

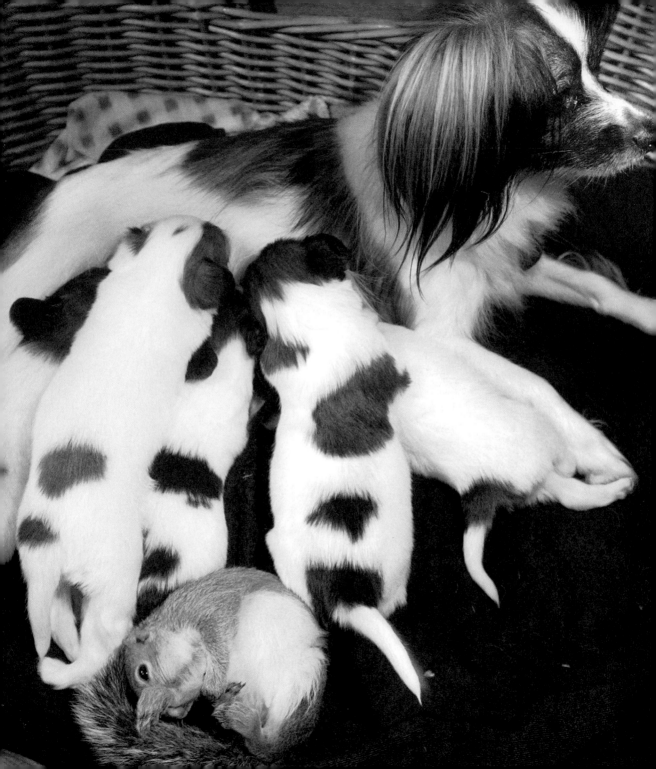

The Papillon and the Squirrel

FINNEGAN FELL. IT WAS A FORTY-FOOT TUMBLE FROM HIS family nest high in the tree, yet somehow the tiny squirrel survived the landing. His future, which looked pretty bleak on the way down, turned brighter when a woman found him squealing at the base of the trunk. She took him to an animal-loving friend for a little TLC.

That friend was Debby Cantlon, a woman who was constantly caring for wildlife in need—injured raccoons, abandoned kittens, any creature down on his luck. She took the tiny smudge of an animal in, gave him a name, warmed him up and bottle-fed him, then tucked him into a bed of heated blankets on the floor of her dogs' unused kennel.

Her papillon Mademoiselle Giselle, meanwhile, was round with pups. And perhaps because of her impending motherhood, the dog was oddly drawn to the unfamiliar squirming creature her owner had brought home. "I went on an errand," Debby recalls, "and when I got back, the kennel was empty." Turns out "Maddie," as Debby calls her, had pulled the swaddled squirrel through the dining room, down the hall, into the bedroom, and parked it next to her own bed. "She was there, guarding that squirrel like it was her own."

Once Maddie gave birth, Debby expected the dog's fascination with the squirrel to fade. Instead, her motherly need to be near the animal got stronger. She went looking for the squirrel just a day after her own pups were born. When Debby gave in and moved Finnegan into Maddie's bed with the puppies, "Maddie started licking, just licking his little head. She was beaming, as if she felt whole now that all her babies were together. I think that a mother is always a mother. Those nurturing instincts are there even if the little one isn't your own."

As the puppies grew bigger and stronger than Finnegan, Debby began putting the squirrel outside so he could learn about the wild life she hoped he'd return to. Maddie would watch and wait for the squirrel to come back to the fold.

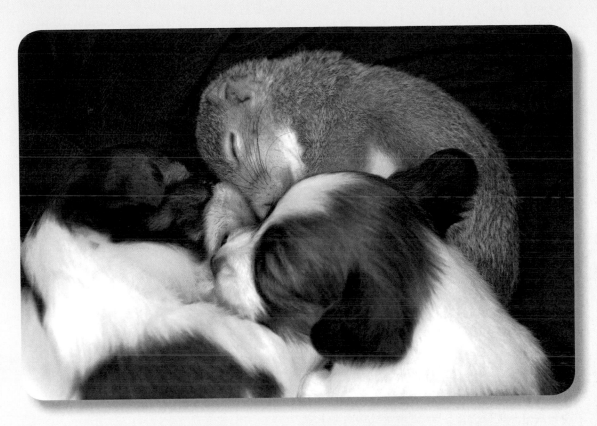

Just around dusk, Finnegan would return to the house, scratch at the door, then nose-dive into the pack and roll around with the dogs. "It was like he was telling them all about his adventures of the day," Debby recalls.

Eventually Finnegan returned to being a wild squirrel full time. When he stopped coming back, "I was sad, for me and for Maddie," Debby says. "But our job was done."

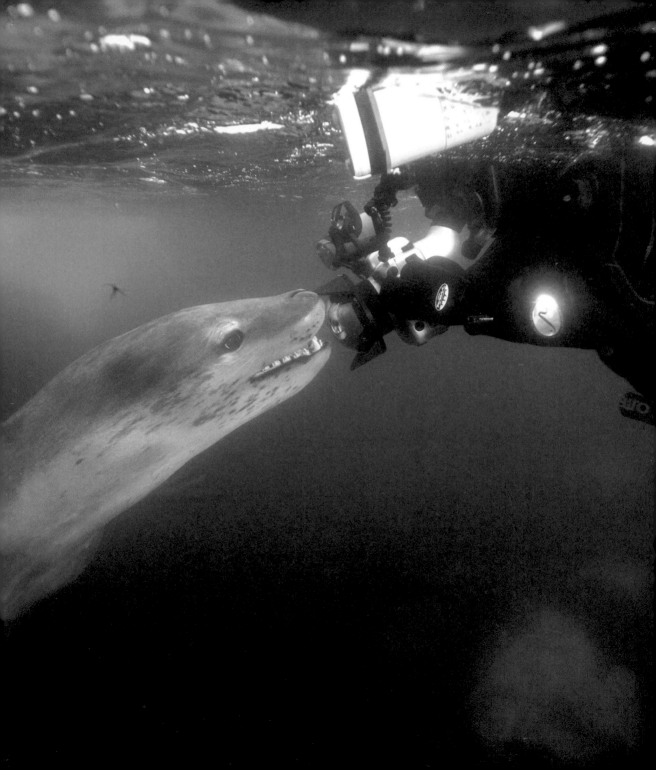

The Photographer
and the Leopard Seal

THERE IS A SAYING THAT LOVING AN ANIMAL AWAKENS the human spirit. For Canadian photographer Paul Nicklen, just a brief encounter with one wild beast not only roused his soul but set it dancing. While on assignment for *National Geographic* magazine, Paul suited up in dive gear and entered the cold blue world of the leopard seal to document these magnificent, and sometimes fierce, marine mammals beneath the Antarctic ice. His goal was simple: Shoot as many photos as possible without being attacked by the thousand-pound territorial beasts, any one of which could easily kill him.

Historical writings by Antarctic explorers include mention of these massive seals threatening men, sometimes following their

movements along ice floes, even trying to grab them. And in 2003, a leopard seal that may have been starving attacked a scientist and drowned her.

The animals' ill-repute makes Paul's experience that much more astounding. A twelve-foot female leopard seal not only took a liking to the interloper, she made efforts to nourish him.

She began the encounter by flashing Paul her wide-open jaws, a threat display that let him know his place without harming him. Then, her dominance established, the seal's mood seemed to swing in Paul's favor. She hovered near him in the water, swimming within arm's reach, as if posing for the camera. In a most astonishing move, the seal hunted down and killed a penguin—its own prey—then offered it to Paul repeatedly, as if trying to feed one of her own young. "It seemed that she was worried about my health. I was clearly too slow a predator to take care of myself," Paul recalls. When the photographer ignored the food offering (always wary of interacting with any wild animal more than necessary), "she brought me live penguins and would place them on my camera dome, then retrieve them for me when they escaped, blowing bubbles in my face as if exasperated by my passive nature." Finally, she ate penguins in front of Paul, "showing me how it's done."

Her sleek beauty amazed Paul. The deadly power turned

LEOPARD SEAL

KINGDOM: Animalia
PHYLUM: Chordata
CLASS: Mammalia
ORDER: Carnivora
FAMILY: Phocidae
GENUS: Hydrurga
SPECIES: H. leptonyx

tender took his breath away. "My heart was pounding and I was elated every time she'd approach. It was the most remarkable interaction I've ever had," he says.

Over the course of several days, this wild creature that dwarfed him in size and strength became a human photographer's greatest companion. At the end of the shoot, "it was hard to leave her behind," he says. "I'd experienced something unique and magical that I'd never forget."

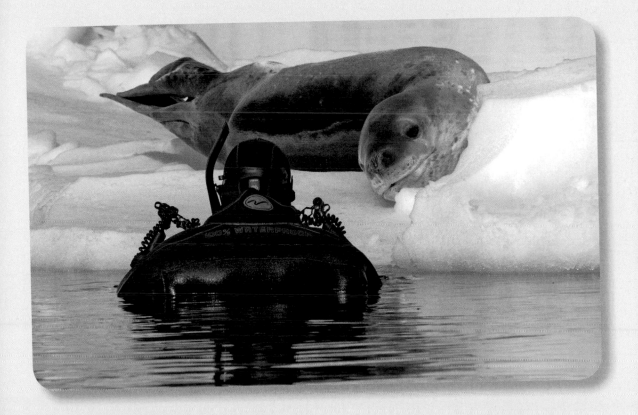

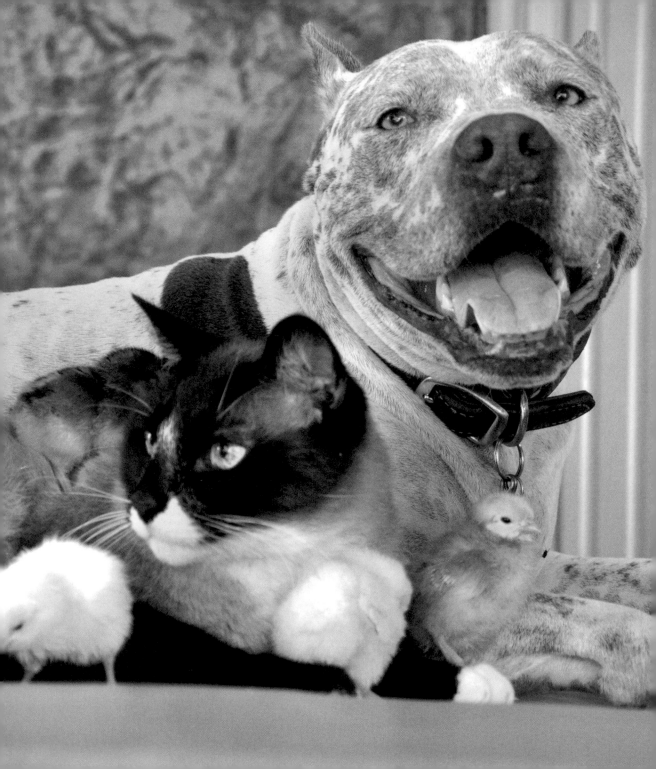

The Pit Bull, the Siamese Cat, and the Chicks

CHICKS DIG SHARKY. THE TINY COTTON PUFFS PERCH on his back, peck at his snout, and use him as a raft in the pool. They're also strangely fond of a Siamese-snowshoe cat called Max, who noses them into line. And Max and Sharky, well, since the cat put the dog in his place with a paw-slap or two, they've gotten along better than fine. To Helen Jürlau, an Estonian who moved to Texas, it's a crazy circus of personalities—just the way she likes it.

She grew up on a farm raising pigs and cows, gathering eggs still warm from the hen. So when she moved to the States with her American husband, Helen was soon bringing animals back to the house, starting with a potbellied pig. "It made me feel at

home," she says. And as the zoo grew, the relationships among the animals took wonderful turns.

Sharky dove into fatherhood before he was a year old and was like an excited big brother to his pups. "He couldn't wait to see them, even more than the female," says Helen. "If I'd ask, 'Where are your babies?' his eyes would sparkle and he'd run off to look for them. He's just in heaven when he's surrounded by all his babies." Those babies came to include Siamese cat Max and the batches of chicks that Helen gets each spring. "When he sees those chicks, his eyes grow huge and he wants to play," she says. He doesn't discriminate between furred and feathered. "I think he just wants to protect anything that's small and helpless. Guinea pigs, rabbits, chicks, the pig, he just won't leave them alone. Everyone gets kisses."

Now, Helen photographs and videotapes the animals to share their bizarre friendships with the world. Some favorite scenes caught on film could be subtitled this way: *Chicks line up atop dog. Chick slides down seated dog's back. Dog, cat, and chicks cuddle together. Chicks ride cat. Cat nuzzles chicks. Dog and cat nap. Dog and chicks play in the pool. Cat slaps dog playfully while riding by on automatic vacuum cleaner.* No doubt Helen's is the only house on the block—in the world?—boasting such antics among its pets.

The animals don't seem to mind being stalked by paparazzi; they just do their thing regardless of the audience. But the clearest bond is the one ever growing between dog and cat. "They make me laugh so much," says Helen. "Sometimes Sharky and Max sit in exactly the same position, one paw stretched out straight and the other crunched inward, like they're mocking each other." And other times, she says, they sprawl out back to back by the pool, two friends just looking at the sky.

SIAMESE CAT

Originally from Siam, the Siamese cat is considered to be one of the few "natural" breeds in existence, which means it developed entirely without the intervention of humans.

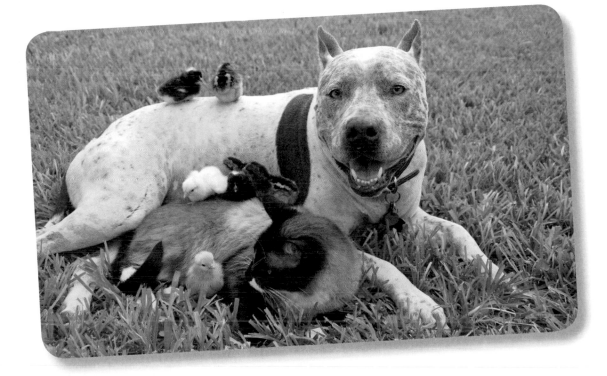

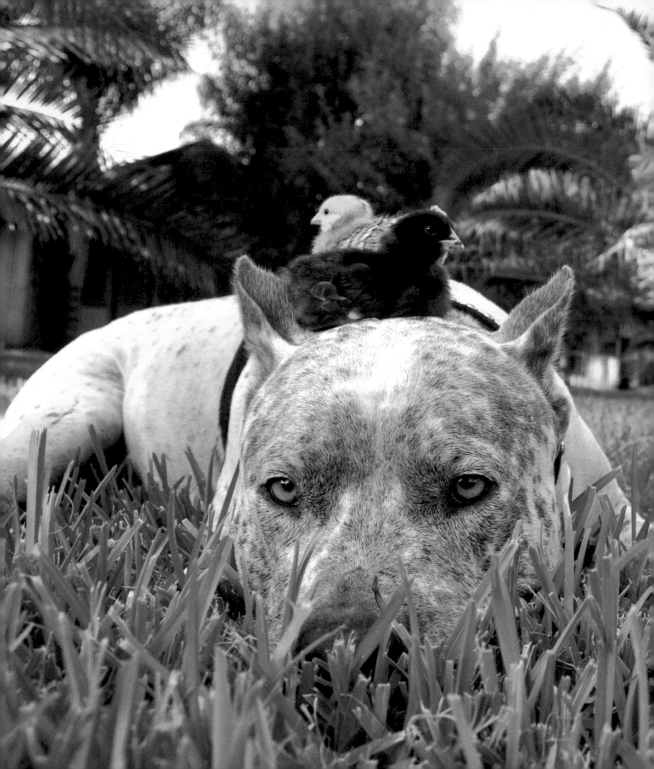

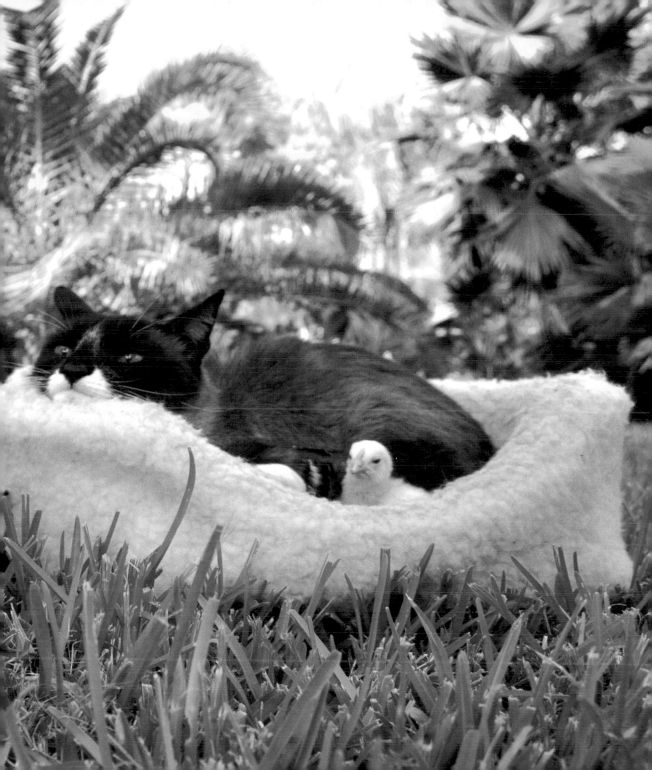

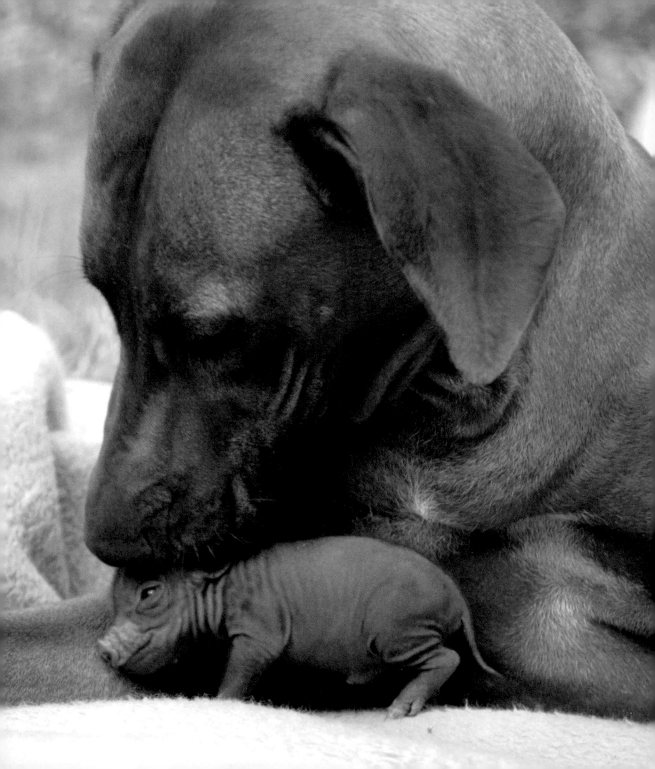

The Potbellied Piglet *and the* Rhodesian Ridgeback

HERE'S A DOG THAT'S BRED TOUGH ENOUGH TO HUNT boar, bobcats, and bears. But give it a wrinkled-sausage of a piglet, and it turns into the tender motherly type.

One cold night in 2009, Roland Adam of Hoerstel, Germany, discovered a pair of recently born pigs on his twenty-acre property. One had already died of exposure and the other was a squirming handful of pinkish skin, chilled to the core, barely alive. A breeding pair of Vietnamese potbellied pigs—a squatter, denser variety of your standard barnyard porker—had taken up residence on Roland's land years before; this was not the first time he had come across such gifts. But in this case he had to intervene, sure that the surviving baby would die from cold or hunger, or would

be snatched up by foxes before morning. He tucked it under his sweater and brought it to the house he shared with Katjinga the Rhodesian ridgeback.

The piglet became little Paulinchen, and Roland decided to hand her off to his dog, who had recently weaned her own litter of pups. It was a good move. Katjinga gave the piglet the soft-puppy treatment, keeping her clean and warm. The pig clearly felt right at home, even trying to nurse—though the dog was no longer producing milk. (Roland and his family took care of feedings.)

A few days later, with pig and hound getting along like mother and son, Roland discovered Paulinchen's birth mother with the rest of her litter, all healthy. He thanked Katjinga for her service and returned the lost baby to the pig family, which eagerly accepted her.

Though the piglet bonded with Katjinga only briefly, it was at a crucial time for the newborn. Back in the porcine life, Paulinchen was a little different from her siblings—a bit tamer and more at ease with other animals. "She knows us and knows Katjinga," Roland says. "When we see the pigs running around and we call to them, Paulinchen will put her head up and look." Sometimes she and Katjinga have a quick nuzzle when the pigs come around sniffing out a meal.

Roland attributes Katjinga's sweet nature to good training (ridgebacks need a lot of socialization) and to the special atmosphere in which they all live. "It is a peaceful area, mostly woodlands," he says. "When there are hunters around, our farm is like a safe haven where animals come together."

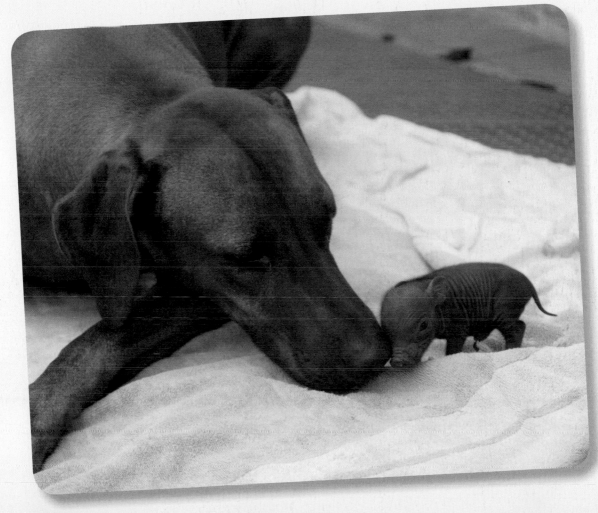

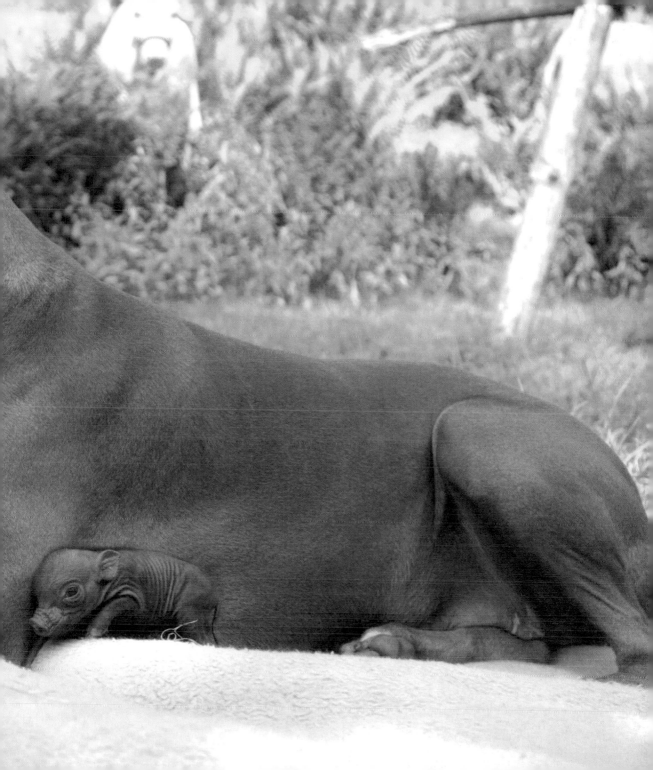

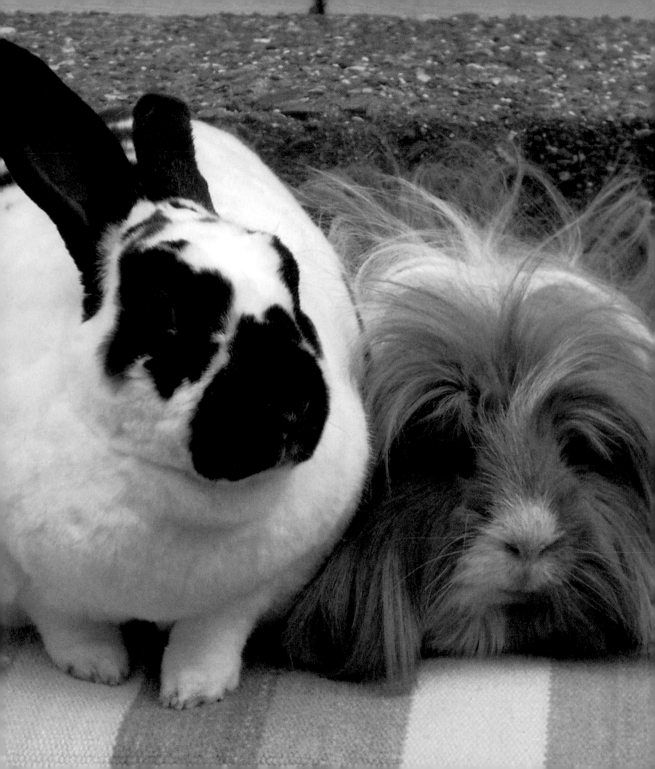

The Rabbit and the Guinea Pig

CUTENESS ONLY GETS YOU SO FAR: OCCASIONALLY, EVEN the Easter bunny gets dumped. But sometimes pink-nosed holiday rejects in Missouri get taken home by Sheryl Rhodes and her daughter, Lauren. And those rescue rabbits get a sweet deal: the freedom to roam in their own room, loads of attention from their devoted owners, and similarly low-to-the-ground friends to pal around with.

In addition to two rabbits, the Rhodes family had a pair of guinea pigs, Timmy and Tommy. But when Tommy died, the owners decided to try introducing Timmy to the rabbits, which had a ten-by-twelve-foot room with food, litter boxes, and all the fixings for an uncomplicated existence. All three are lovers of crunchy

vegetables and are litter trained. It seemed a perfect matchup.

A turtle also inched around the space, though he kept to himself.

"The rabbits had never really bonded with each other," says Sheryl. "But when Timmy offered his companionship, especially to the one named Baby— the snubbed Easter bunny—we were thrilled. They really warmed up to each other. There were lots of nose touches and nuzzles between them." If Baby was feeling spry and hopping around, Timmy would squeal and waddle after her, she says. "But mostly they were very lazy critters together, just lying around."

When Sheryl or Lauren took Timmy out of the room for petting or grooming, Baby would hop around looking for him, poking her nose into spots where the pig might hide. Meanwhile, the rabbits had a cardboard box set up off the floor so they'd be able to get away from Timmy if they chose to. But within a short time, one of the animals chewed a hole in the bottom of the box. "Suddenly, Timmy was in there, too. I guess if Baby had wanted him out, she could have gotten rid of him. But she didn't seem to mind."

GUINEA PIG

KINGDOM: Animalia
PHYLUM: Chordata
CLASS: Mammalia
ORDER: Rodentia
FAMILY: Caviidae
GENUS: *Cavia*
SPECIES: *C. porcellus*

RABBIT

KINGDOM: Animalia
PHYLUM: Chordata
CLASS: Mammalia
ORDER: Lagomorpha
FAMILY: Leporidae
GENUS: *Oryctolagus*
SPECIES: *Oryctolagus cuniculus*

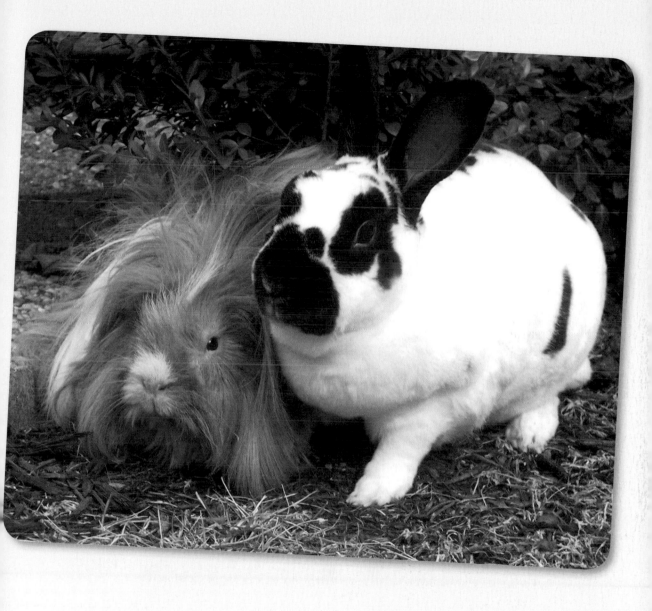

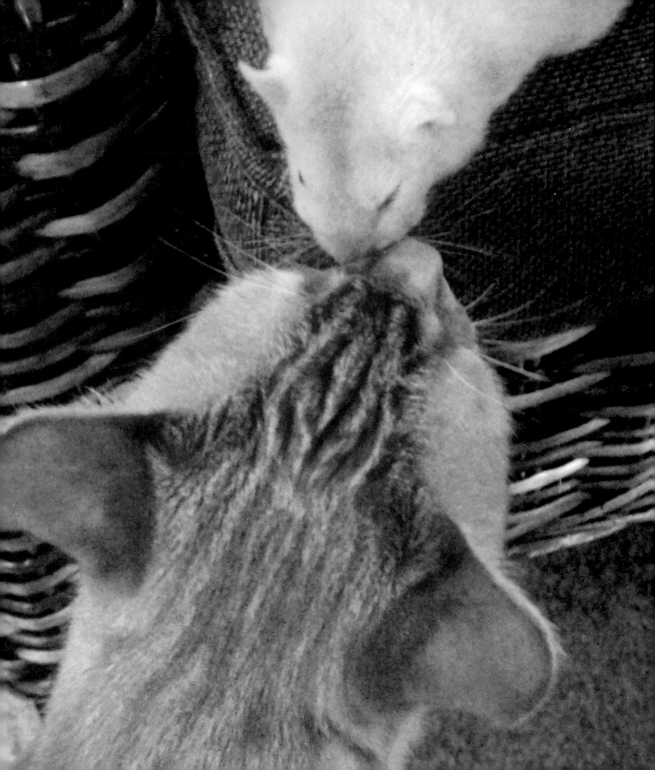

The Rat and the Cat

RATS. THEY'RE FILTHY, DISEASE-CARRYING PESTS THAT skitter through trash-strewn alleyways with those awful hairless tails trailing out behind them. Right?

Set aside such notions. Rats are actually smart little mammals with an unfair reputation for doing nothing but skulking about. True, the big brown ones peering from city sewers are hard to love. But just consider them as survivors. Cleaned up, their kind can make great pets. They're also, of all nonrat things to be, ticklish, and they've been shown to experience convoluted dreams about recent happenings, just as humans do. And in the case of Peanut—a white rat owned by Maggie Szpot of Ohio—they are capable of becoming smitten with their mortal enemy, the cat.

Ranj the cat came to Maggie as a stray, so she expected that with rodents in the house, his hunting instinct would rear its feisty head. Not so! Ranj showed only curiosity toward the numerous rats Maggie rescued. Peanut and Mocha, a pair that Maggie got at the same time, were no exception. "When I first brought them home, I put them in a fenced-off area, but Ranj just jumped right in and started sniffing them. He was very calm—there was no aggression at all," she says.

Soon after they met, Maggie says, "Peanut developed a special liking for Ranj and began to follow him everywhere. Ranj liked her back, but would sometimes try to avoid his pesky friend by hopping onto anything off the ground. Peanut would just climb up after him!"

Nowadays, Peanut loves to snuggle with Ranj and will crawl fully under the cat's haunches when he's seated. The rat appears soothed by the cat's presence, and will close her eyes as she snuggles up to his furry warmth. Ranj sometimes gives Peanut a tongue bath or rubs his head against her when she gets close to him, Maggie says. In return, Peanut licks Ranj's face or scrambles over his stretched-out body. Though Mocha is less friendly to the cat and will chase and bite his feet, he joins Peanut and Ranj at mealtime. It's an odd scene: two rodents munching kibbles from Ranj's bowl as the cat stretches his neck down between them for a bite, "each without a care in the world."

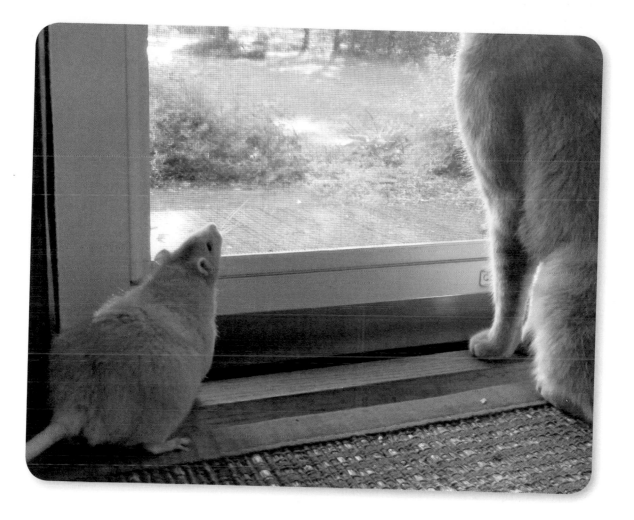

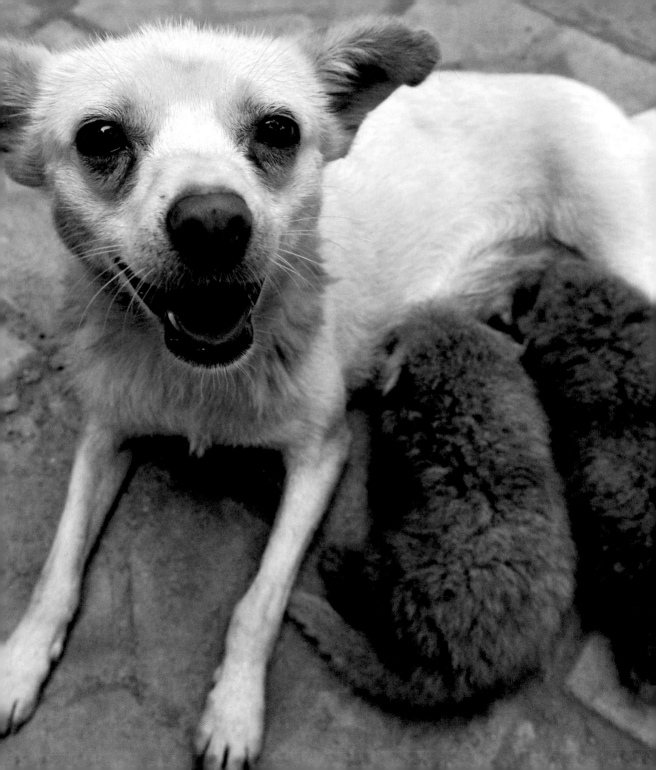

The Red Pandas and the Mothering Mutt

THEY'RE EXTREMELY PRECIOUS, THESE TINY RED PANDAS, and not just because of their high cuteness factor. In the wild, hunting and habitat loss threaten the species with extinction, and *Ailurus fulgens* is protected by law. So the success story of these two panda cubs in a Chinese zoo is sweet indeed.

Red pandas, also known as lesser pandas, are only distantly related to their big black-and-white namesakes. And they're more closely related to raccoons than to dogs, but these two took to a canine "mom" as if she were the closest of kin.

The mother panda had recently been moved from the Shaanxi Zoo to the Taiyuan Zoo in northern China's Shaanxi Province. Beneath her furry plumpness, the bear was pregnant, unbeknownst

to zookeepers, and in her new environment she gave birth prematurely. Under the stressful circumstances, the mother abandoned her pups, leaving humans scrambling to find a way to keep the babies from starving.

Caretaker Li Jin Bang acted as surrogate parent for the first few days after the pups were born. Like any good mother, he fed them every two hours, day and night, with syringes full of specially formulated powdered milk. Meanwhile, the zoo turned to the local media for help finding a more appropriate panda substitute. The staff hoped to find a smallish dog that had given birth recently, with plenty of milk and a calm demeanor that would not frighten the new babies. (Dog milk is close enough in makeup to that of pandas that the young would get most of the nutrients they needed without supplements.) Fortunately, a supplier for the zoo who lived on a nearby farm heard the call and brought his scrappy little mixed-breed, who was heavy with milk for her own triplets, to the rescue. One of her own pups came along as well, to ease the transition and keep the mama dog focused.

Quickly the pandas learned to suckle from the canine, and she took to her new job naturally, sometimes even letting the pandas eat before her own pup got access. But the new mom was more than a food provider to the little bears. She treated them as her own, licking them at both ends to keep their bodily functions run-

ning smoothly. A red panda mother, who may give birth to up to four blind cubs at a time, will spend sometimes 90 percent of those first days nuzzling her young and getting to know their individual scents. Their adopted mom was similarly attentive when the pandas needed her most. And the bears, their

eyes still squeezed tightly shut and their squeals barely audible, responded by slurping up her milk with gusto, growing healthy and strong.

Eventually the pandas were weaned, but for a long time after, their surrogate-mother dog lingered outside the Panda House, trying to get back in. Zoo staff members were touched to see how the dog's protective instinct held strong even after the bears outgrew their need for her care.

For a time, the dog and all of "her" offspring lived together at the zoo, where visitors could marvel at the interspecies group. Once the bears could crawl, Li walked the whole family and let them exercise for hours each day. "The pups—both panda and dog—climbed and played like naughty boys," Li says.

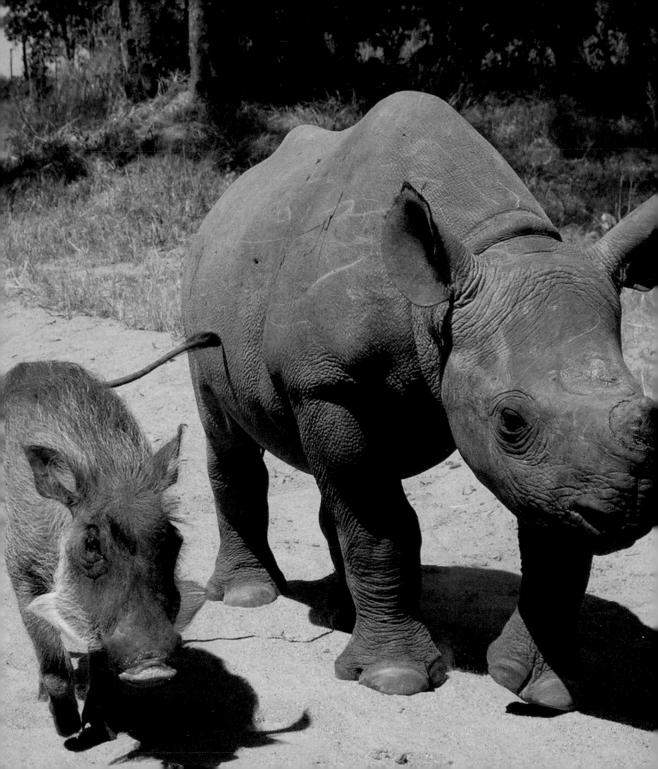

The Rhinoceros, the Warthog, and the Hyena

A RHINO, A WARTHOG, AND A HYENA WALK INTO THE BEDROOM... the lead-in for a dreadful joke? Nope. It's an actual scene from the Imire Game Reserve in Zimbabwe, where these three species for a time were housemates and playmates alongside a family of humans.

It started with the rhino, Tatenda. For years, Jude Travers and her family had been successfully breeding black rhinoceroses for national parks, an effort called the Black Rhino Conservation Project. This species is extremely endangered, with only about 4,000 animals left in the wild, so every individual is a precious thing. One horrible night, poachers seeking rhino horns, which are highly valued in traditional Asian medicine and as decorative items, stole

onto the Imire property and killed the entire herd, even though the rhinos had been dehorned surgically to dissuade just this type of attack. When the Traverses arrived on the scene, baby Tatenda, born on the ranch three months before, was cowering beneath some straw, the only survivor. He was covered in his parents' blood and in shock from the ordeal. The loss of the herd was devastating, but Jude and her family had to quickly set aside their sorrow and anger and focus on getting Tatenda back on her feet.

Enter Poggle, the warthog. Shortly before the rhino massacre, "a little pincushion of a warthog joined the household," recalls Jude. "He was the size of my hand, and with just a sniff, he instantly recognized the baby rhino as a future friend and companion." The timing couldn't have been better, as Tatenda would rely heavily on Poggle's affection—as well as that of Jude Travers—as he healed from his emotional wounds.

Finally came the hyena, Tsotsi, another orphan Travers rescued about ten months later. "He was the devil initially, with his beady little eyes and nocturnal ways, hiding out in his cave (a blanket-covered basket)," Jude says. "It took some months for the friendship to develop; it's a slow-going process for a hyena to learn trust."

Under Jude's affectionate care, the trio thrived and soon took to one another like siblings. On any given Sat-

urday morning, the whole mess of them could be found in the Traverses' bedroom—the hog under the sheets, the rhino with his chin on Jude's lap for a scratch, and the hyena tucked away beneath the bed. Together with their human caretakers, the bizarre trio would laze about before breakfast. At (human) mealtime, they'd often saunter to the table and demand milk, treats, or another round of affection. Out in the garden, the unconventional herd would chase and playfight (Tsotsi was often the instigator, with nips to Poggle's backside), munch flowers, and nap together under the mulberry trees. And the three would go on walkabouts in the bush, sometimes with Jude or another Travers leading the pack and an orange house cat bringing up the rear.

<div align="center">

HYENA

KINGDOM: Animalia
PHYLUM: Chordata
CLASS: Mammalia
ORDER: Carnivora
FAMILY: Hyaenidae
GENUS: Hyaena
SPECIES: H. brunnea

</div>

Eventually, the Travers family made preparations to release Tatenda and Poggle together in a wilder part of Imire about eight miles away. Both needed to get on with more natural lives among their own kind. (Tsotsi, still a bit young to mate, would remain with the Travers family for the time being.) For Jude it was like turning away loved ones—the rhino, especially, held a big place

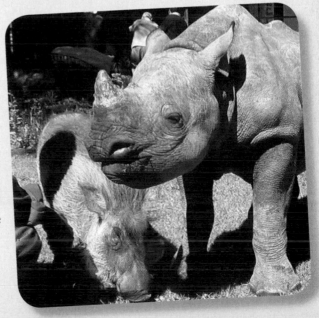

in her heart—but she knew it was right for the animals. "It's a tragedy when human actions result in orphans that need this kind of care," Jude says. "Being able to hand-rear them and then put them back into their natural environment, where they can rely on their true instincts, that's the ultimate goal."

The transition of rhino and warthog to the reserve land was a success. They rambled in tandem at first, but eventually the hog "went wild," mated, and produced three little pigs of her own. Tatenda eventually turned his attention to other rhinos on the 11,000-acre property, where he is "adored by all the girls" (girl rhinos, that is), Jude says. Tsotsi, who had been left alone after his friends had been transitioned to the wild, wandered off into the bush one day and never returned.

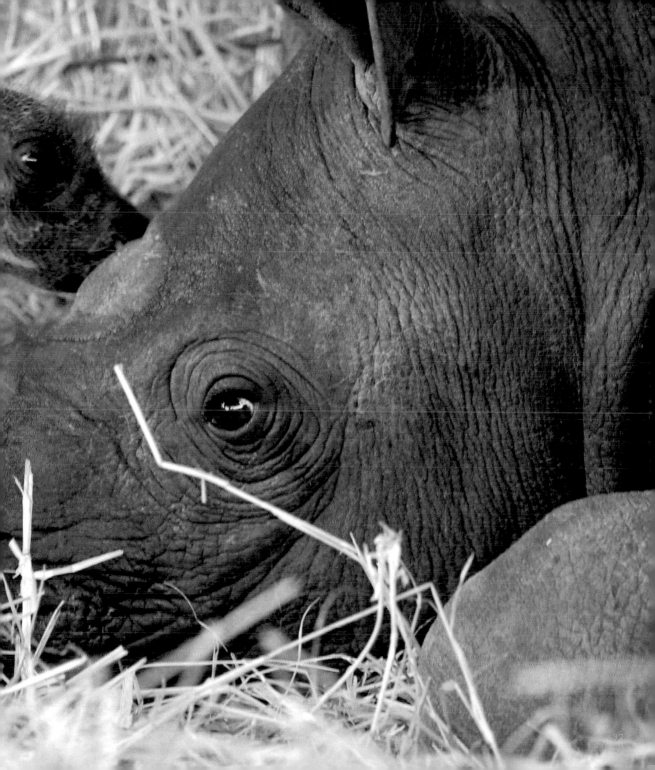

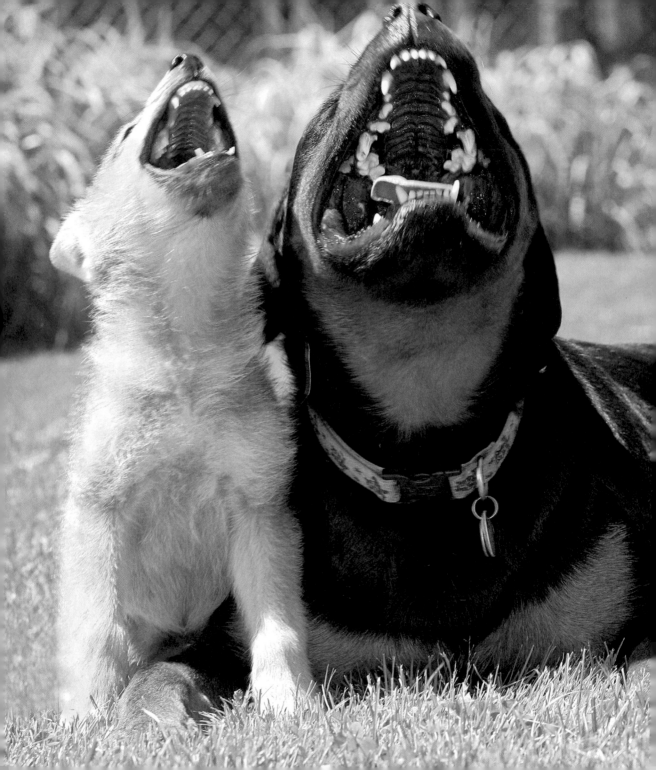

The Rottweiler
and the Wolf Pup

THE BIRTH OF THE WOLF PUP WAS TOTALLY UNEXPECTED. Staff at the Kisma Preserve in Mt. Desert, Maine, thought the young adult pair too young to breed, so they weren't watching for a pregnancy. But then, out came a pup—born to a mother not yet mature enough to understand her role as parent. "There was no aggression," says the preserve's director, Heather Grierson, "but she had no maternal instinct whatsoever. She just didn't know what to do with it." Staff members at the preserve were used to bringing work home with them. In this case, Heather decided to offer her house to rear the baby animal, a helpless bundle with eyes still tightly shut.

Ulrok the rottweiler was there to greet them when Heather

WOLF

KINGDOM: Animalia
PHYLUM: Chordata
CLASS: Mammalia
ORDER: Carnivora
FAMILY: Canidae
GENUS: Canis
SPECIES: C. lupus

arrived with her tiny charge. "Right from the beginning, he took excessive interest," Heather says. "I misinterpreted it at first, thinking he might get overly rough. Plus, he's huge and young and clumsy and might have hurt her by mistake. But he didn't. Instead, he was amazingly maternal." When the puppy whimpered, "he wanted to clean her top to butt, normally the mother's job. Ulrok simply took over. If he could have nursed her, he would have."

The wolf was completely responsive to the rottie's overtures, happy for the attention. And after realizing Ulrok wasn't content unless the pup was within licking reach, Heather let them share a bed so they could cuddle. The still-awkward pup tried to play with the big dog, and even licked Ulrok's mouth and chewed his tongue to try to get him to regurgitate food, as wolves do in the wild. "He'd neutralize her with his paw if she got too excited, but Ulrok was so patient with her!"

The pup's wolflike ways showed at mealtime as well. When it comes to food, wolves and well-fed domestic dogs are very different animals—not so much in what they like to eat, but in the lengths to which they'll go to protect their lunch. Any self-respecting wolf challenged for her food will curl her lip and snarl, eyes wild and stance wide. The pup did the same, and Ulrok respected

her space. "Here was this five-pound pup growling at this 120-pound dog, and he'd just back off and let her eat," says Heather. "People think that if you raise a wolf in captivity, it'll be like a pet dog. That's not true. They are hardwired in different ways."

That difference in temperament and behavior is one reason Heather wanted to make sure the wolf was exposed to her own species as soon as possible. So when the time was right, the pup was introduced to an old female wolf at the preserve named Morticia, who had been living alone for years. Happily, the two bonded from the start. "The pup breathed new life into the old wolf, who became more

ROTTWEILER

The rottweiler, which originated in Germany, is one of the oldest herding breeds, dating back to the Roman Empire when they helped herd cattle for the Roman legion.

active having a young animal around. She was soon regurgitating food for her and teaching her wolf mannerisms and behaviors," says Heather. More convinced than ever that the pup knew what she was, the preserve staff felt confident in plans to integrate her into one of their captive wolf packs when the day came that elderly Morticia would no longer be there for her young companion.

As for Ulrok, whose breed is known for its herding and guarding instincts, he's now offered his parenting services to numerous animals at the facility, including tiger cubs, a baby gibbon, and even an injured leopard tortoise. "He really is the peace-love-and-happiness rottweiler of the world," says Heather. "He was just destined for this life."

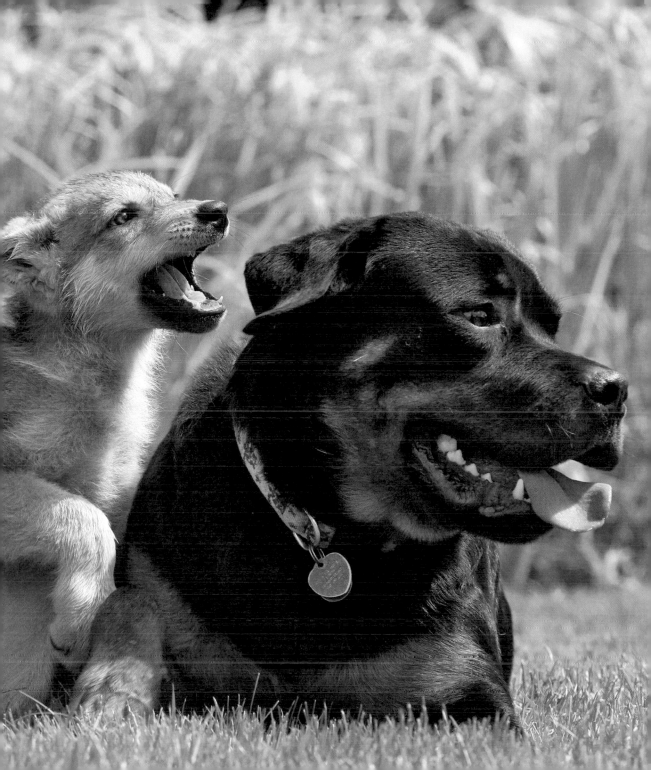

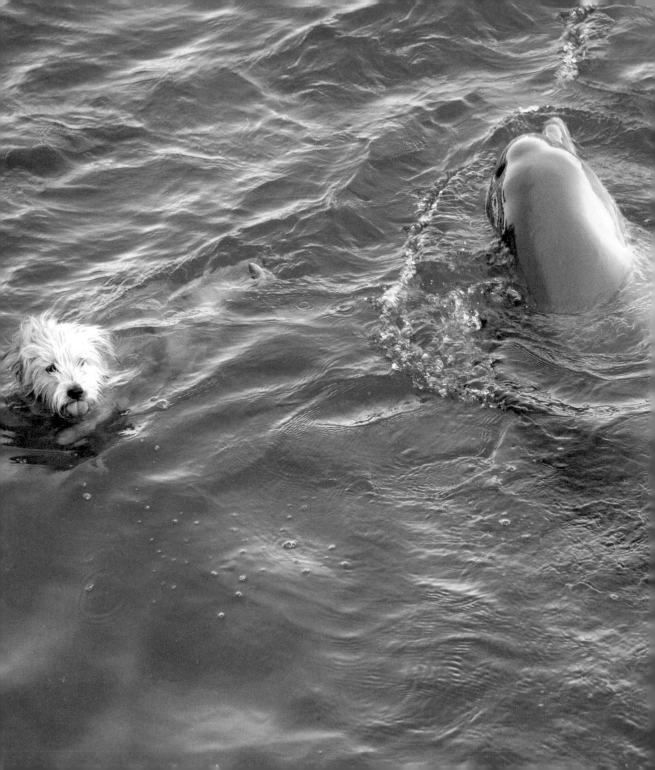

The Salty Dog
and the Dolphins

ON THE SOUTH SIDE OF EILAT IN ISRAEL, WHERE THE Red Sea creeps onto sandy, tourist-packed shores, a shaggy dog took a leap of faith.

His name was Joker, and one warm day in the spring of 2000 he simply showed up at Dolphin Reef, a beachy tourist attraction specializing in encounters with the popular marine mammals. He belonged to a family in town, but he seemed more at home on the Reef's wooden pier overlooking the sea.

At first, the owners weren't happy about their canine visitor. They were concerned that he'd chase the cats, chickens, and peacocks that lived on the property. But Joker kept coming—traveling every day from wherever he laid his head at night—and never

raised a paw to the other animals. In fact, he seemed utterly disinterested in all species but one: the dolphins.

Dolphin Reef has a population of eight bottlenose dolphins all fathered by a male named Cindy, the so-called Don Juan of the pod. (Yes, "Cindy" is a male.) At times the animals have been given free access to the open sea and allowed to choose between the Reef and the wild. So while they do encounter humans and receive food, their behaviors remain quite natural—including their play.

Those acrobatics held Joker's interest for many days. He sat on the dock and observed the dolphins as they gathered and squealed and splashed and rocketed through the waves. Then one day during feeding time, Joker abandoned his dry observation post and leaped in.

The dolphins appeared to welcome the dog into their world, so after that first leap his swims became routine. For a time, the Reef staff tied Joker up during feedings to keep him from distracting the dolphins as they ate. Soon the pup realized that he was welcome in the water any time but during a meal. He learned to read the aquatic mammals' signals and "would jump in only when the dolphins were teasing him or inviting him," says Tal Fisher, one of the dolphin trainers.

Joker became a bit of a star, and people who saw him making his daily sojourn from town would pick him up—despite his salty-dog stink—and drop him at his favorite spot. He always headed straight for the wooden

BOTTLENOSE DOLPHIN

KINGDOM: Animalia
PHYLUM: Chordata
CLASS: Mammalia
ORDER: Cetacea
FAMILY: Delphinidae
GENUS: Tursiops
SPECIES: T. truncatus

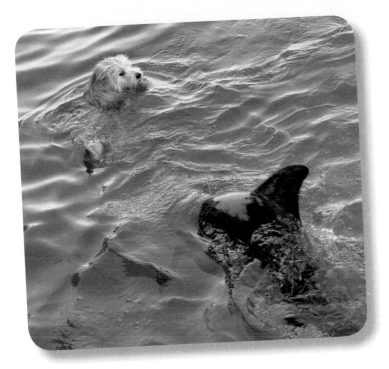

pier above the water, where his playful friends would greet him.

Eventually, the dog's owners realized Joker was happiest at the Reef, and they let the mutt move in permanently with the facility owners so he'd have easy access to his aquatic playmates. To this day, he spends many nights sleeping on the dock, ready to start the morning by barking at the dolphins as they congregate below. Then he jumps into the water to frolic with them. "They react by swimming around him and splashing with their tails," says Tal. "They even speak to him." How dog barks and dolphin squeaks translate across species is a mystery. But the mutually curious animals seem to have discovered a shared language in play.

The Seeing-Eye Cat and the Blind Mutt

WHO HASN'T WONDERED AT THE AMAZING PARTNERSHIPS between seeing-eye dogs and the people they help navigate through a dark world? Dogs are specially trained to be the eyes of the blind, and remarkable friendships ensue from this very intimate experience between two species.

But have you ever heard of a seeing-eye cat? Here's one case, of a tabby named Libby. She was not only self-trained to assist the blind, her charge wasn't even human—she was canine.

Libby, a stray cat, was adopted by Terry and Debra Burns of northeastern Pennsylvania in 1994. No bigger than a baseball when the Burnses brought her home, the tiny cat adapted well to her new surroundings, including Cashew, the lab mix that was

already living there. Raised together, the animals got along fine, but for most of their lives they had limited interactions.

But around age 12, Cashew began to lose her sight. And as the dog's vision degenerated, Libby the cat suddenly became protective of her lifelong housemate. She'd bed down in the door of the dog kennel where Cashew slept, seeming like a devoted caregiver as the old girl napped behind her. She'd hang out just beneath Cashew's chin as the unseeing pooch maneuvered through house or yard. Together they'd approach a food dish or find a sunny spot on the patio to share. Everywhere Cashew went Libby was there to guide her. They seemed to communicate, Terry says. "It was as if Libby would say, 'Hey, watch out for that bench there,' or, 'Here's your water dish!'" The cat also began showing up along the route where Terry walked Cashew, sometimes watching from a distance, other times padding along beside them—"letting the dog know she was nearby, watching over her," he says. "They only got closer and closer as time went on."

When Cashew finally passed away, at nearly 15 years old, Libby seemed to wonder where he had disappeared to, and would go looking in the dog's old haunts. She never took to the other family dog in the same affectionate way. No other companion, it would seem, could ever replace the unlikely one she'd had in that old blind mutt.

Many hospitals have dogs and cats "on staff" to help with patients dealing with a number of ailments, from dementia to high blood pressure.

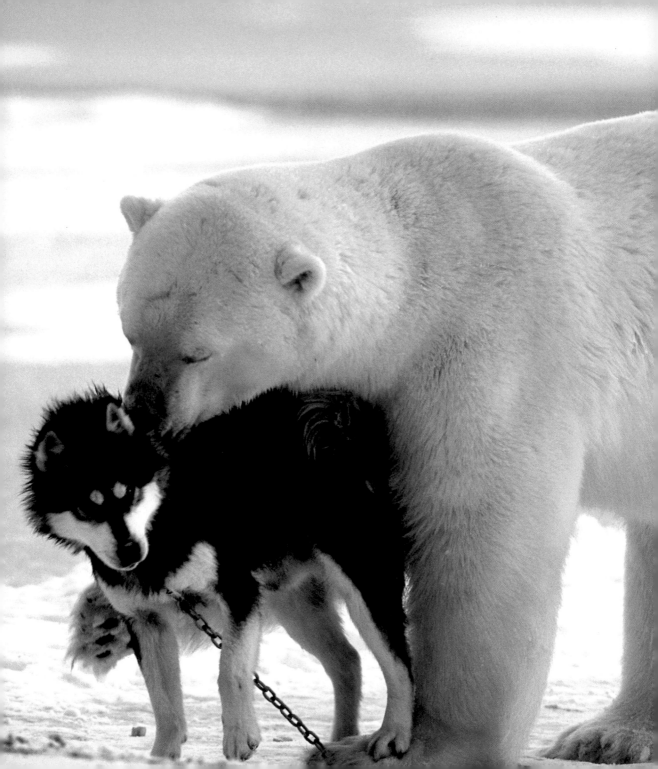

The Sled Dog and the Polar Bear

IN THE FAR REACHES OF THE ICY NORTH, IN A CANADIAN town called Churchill, a photographer witnessed a stunning interspecies interaction.

Churchill is known for its polar bears—a particularly bold population living in unusually close proximity to people. The line between wilderness and civilization is often blurred as the bears venture from their icy feeding grounds into town to pick through trash for an easy meal. And in a place where dogsleds are a common form of transport, the scrounging bears are bound to meet up with canines from time to time.

Rogue bears have been known to kill sled dogs. So one November day, when photographer Norbert Rosing noticed a huge

POLAR BEAR

KINGDOM: Animalia
PHYLUM: Chordata
CLASS: Mammalia
ORDER: Carnivora
FAMILY: Ursidae
GENUS: Ursus
SPECIES: U. maritimus

male approaching an area where several dozen Eskimo dogs were corralled, he worried for their safety. "Most of the dogs started barking, pulling on their chains, as the bear got close," he recalls. But there was one dog that stayed calm, standing apart from the others. As Norbert watched, the bear moved toward the unruffled pup. And then, most unexpectedly, the bear lay down, rolled over, and reached out his massive paw, as if asking the dog to play while promising no harm.

The dog was initially wary, but as his confidence grew the two began to play. Both were gentle at first—the bear pulled on the dog's leg, then lightly bit its hip, and the dog responded in kind. When the bear tested his playmate with a harder bite, the dog yelped in pain. "The bear released him right away, then came back and started playing again, more carefully," Rosing says. "By the end, they were scrapping like old buddies, with the bear lying on his back and the dog jumping on his belly. The bear would take the dog's head between his paws as they wrestled around. It was an incredible sight."

The animals roughhoused for about twenty minutes before the bear left. But for several days afterward he returned and the pair resumed their game. Similar interactions have since been reported in Churchill, sometimes with multiple bears

SLED DOGS

The Siberian husky and the Alaskan malamute are two of the best-known purebred sled dogs, and are known for both their stamina and speed.

playing with multiple dogs at once. Bears have even been seen protecting the dog pack by running off less affable relatives.

Unfortunately for all concerned, these kinds of interactions with polar bears—rare as they are—may one day be a thing of the past, remembered only through stories like this one and photographs. Climate change is melting the Arctic ice at an alarming rate. Many scientists warn that polar bears, which live largely within the Arctic Circle, are declining in numbers so great that they are vulnerable to extinction in the near future. The bears rely on vast expanses of ice and big floes to use as platforms from which to hunt seals. As that ice becomes scarcer, the carnivores will suffer—and will no doubt be more likely to lumber into towns like Churchill looking for food, not friendship, from sled dogs.

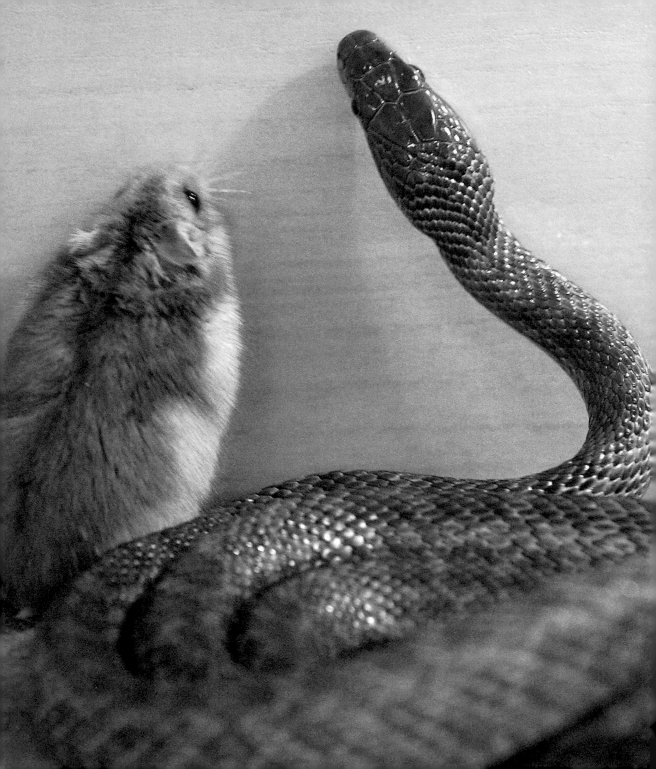

The Snake and the Hamster

DEAR SNAKE OWNERS AND FRIENDS OF SMALL RODENTS: Please don't try this at home. In what is arguably one of the stranger cases of interspecies relations, a four-foot rat snake at the Mutsugoro Okoku Zoo in Tokyo, Japan, seemed content to cradle a dwarf hamster within its muscular coils instead of clutching it in a death grip and swallowing it whole.

A keeper at the zoo, who was interviewed about the animals by a videographer, said that when he first captured the snake, it fasted for about two weeks, uninterested in frogs or other small animals that were offered as meals. The keeper finally placed a hamster in the tank, assuming a warm and frisky mammal would be just the thing to pique the snake's appetite.

At first the interaction seemed normal enough. The hamster, jokingly called Gohan—"meal" in Japanese—roamed the tank and sniffed the snake all over. The snake, Aochan, sensed the heat of the animal and "tasted" the air around it with its flicking tongue, as it would do before any meal. But not only did the snake not attack and eat the hamster, it appeared to the keeper that the two natural enemies began showing affection for one another. Soon Gohan was climbing up and over the snake's body and fidgeting among the coils as if making a bed there. Then it settled in the snake's embrace, and Aochan even adjusted its body to accommodate the little creature. "I sensed that the relationship wasn't about eating, but was about friendship," the keeper said in the interview. The animals remained together without incident.

HAMSTER

KINGDOM: Animalia
PHYLUM: Chordata
CLASS: Mammalia
ORDER: Rodentia
FAMILY: Cricetidae
GENUS: *Mesocricetus*
SPECIES: *Mesocricetus raddei*

It's a lovely idea, that a snake known for its quick strike and power to suffocate warm-blooded animals could be a comfort to a nervous rodent. Of course, there are more likely explanations. Rat snakes will hibernate during cold weather, with a drop in metabolism to conserve energy, and the hamster–snake incident took place in autumn. So it's likely that Aochan simply wasn't hungry, his predatory drive in low gear. A summertime introduction

RAT SNAKE

KINGDOM: Animalia
PHYLUM: Chordata
CLASS: Reptilia
ORDER: Squamata
FAMILY: Colubridae
GENUS: *Elaphe*
SPECIES: *E. climacophora*

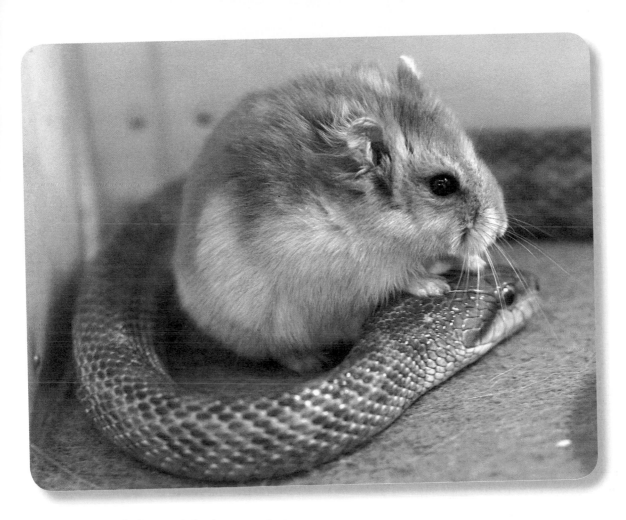

to Gohan might have ended very differently indeed.

Regardless of the reason for the animals' peaceful interaction, the behaviors were intriguing, and drew many visitors to the zoo to see a snake and a rodent in an unexpected embrace.

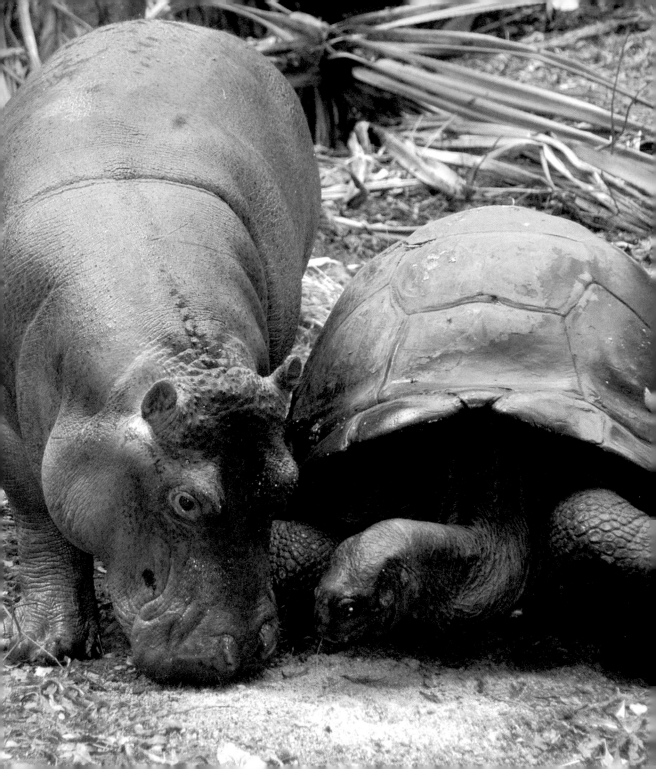

The Tortoise

and the Hippo

IT HAS FAST BECOME ONE OF THE MOST FAMOUS EXAMPLES of interspecies friendship ever told. Reptiles aren't typically known for their warm, fuzzy natures. Nor are hippos.

The story goes that when the deadly December 2004 tsunami hit the Kenyan coast near the village of Malindi, the waves swept away all but one hippo of a pod wallowing in the Sabaki River. This lone survivor was a 600-pound baby that villagers managed, with colossal effort, to capture and transport to the Haller Park Wildlife Sanctuary in Mombasa.

Hippos can be aggressive and ill-tempered, even toward their own kind. So baby Owen, named after one of his human rescuers, was placed in an enclosure along with small, gentle

animals like vervet monkeys, bushbucks, and, as it happened, a 130-year-old Aldabra giant tortoise named Mzee.

That's when strange and wonderful things started to happen. Owen immediately approached Mzee and crouched down behind him as if hiding behind a great boulder. Mzee moved away, seeming annoyed, but the hippo persisted. And by the next morning, the two had managed a sort of awkward cuddle. Hippos in the wild crowd near each other, but except for mothers and young, they don't really bond socially. Giant tortoises also hang out in herds without forming any great attachments. The young hippo, perhaps craving motherly attention, found something comforting in an old, set-in-his-ways reptile—a pairing as unlikely as they come.

Hippo babies usually stay with their mothers for four years, learning how to be hippos. In this case, Owen began learning how to be a tortoise. According to Haller Park's manager, Paula Kahumbu, he began copying Mzee's feeding behaviors, chewing on the same grasses. He'd ignore other hippos bellowing elsewhere in the park, and he was most active during the day, which is the opposite of typical hippo behavior but in line with tortoise preferences. The two followed each other around, wallowed together in the pond,

and slept side by side, meaty torso against timeworn shell. Owen became protective of his reptile companion and affectionate toward him, licking Mzee's face as the tortoise rested his head on Owen's belly.

Scientists have been most fascinated with how the two animals developed their own physical and verbal language. With gentle nips and nudges to feet or tails, they told each other when to move and in which direction. They sounded off, back and forth, with deep rumbling sounds not typical of either animal. "What strikes me is how sophisticated their mutual communication system became," says animal behaviorist Barbara King. "It's a dynamic dance between two species with no preset program on how to deal with each other. And it can't just be instinct, because one was shaping its behavior to the other."

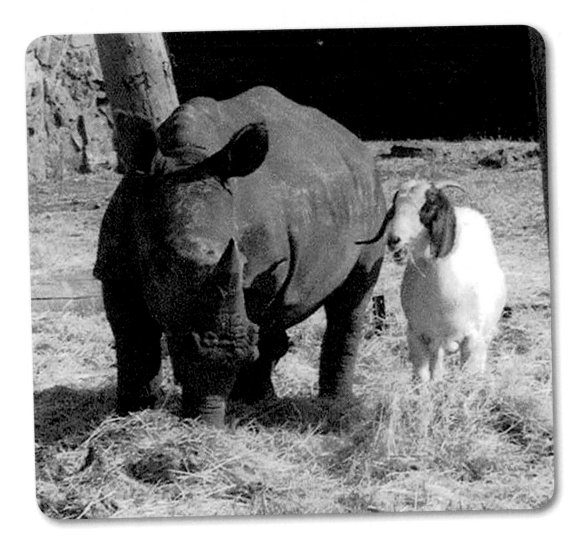

The White Rhino
and the Billy Goat

THE RHINO AND LION NATURE RESERVE, LOCATED ON the high plateau region of inland South Africa, is named for two of its most charismatic beasts. Owned by stockbroker Ed Hcrn, the place in its early years was just an old farm with a modest collection of two white rhinos. It now houses more than 600 game animals representing twenty-five species.

One of the animals was a six-month-old rhino calf that had been brought to the reserve after her mother was killed by poachers. The calf was spotted cowering by her mother's carcass, and it was decided she should be hand-reared until she was old enough to fend for herself among other rhinos. But a half-year rhino gulps down gallon after gallon of milk each day, and acquiring a trough of

the drink on a daily basis was difficult. Fortunately, a South African dairy supplier offered to sponsor enough milk-replacement formula to feed the beast. The charitable company was called Clover. And from then on, so was the rhino.

Clover craved constant attention, says Lorinda Hern, the daughter of the reserve's owner. That's not surprising for an animal typically inseparable from its mother for its first eighteen months of life. For a while, a human handler kept her company—virtually a full-time job. At this point, the youngster's daily milk intake was at fourteen gallons; at mealtimes she'd impatiently await her massive drink with childlike squealing and foot stomping. But as the rhino ballooned to over 600 pounds, the position of rhino chaperone became increasingly dangerous. Although Clover was extremely gentle, her sheer bulk meant that she could easily crush a human foot—or worse—by simply being too rambunctious. Human efforts at discipline were useless at tempering the little rhino's exuberance. And anyway, it was not ideal to let her become too attached to humans, as it would make her an easy target for poachers in the future.

But solo living wasn't good for Clover, and she soon fell ill. A local vet diagnosed her with a stomach ulcer, a condition he believed was related to stress and loneliness. Clover needed a new friend, but no other young rhinos were on hand. So, in an experimental move, a tame adult billy goat was ushered into Clover's pen.

As expected, Clover was very curious about the new resident, sniffing and nudging him at every opportunity. Unfortunately, her

new neighbor was annoyed by the invasive behavior. He charged at her, head lowered aggressively in the same way that goats establish a hierarchy when they're among other goats. Clover meekly retreated to a safer distance. But within minutes she'd take her chances and approach again. Even though Clover loomed like a giant over the goat, the smaller animal wasn't intimidated and proved himself the dominant member of the pair. Clover was so thrilled at having a friend—even a moody and temperamental one—she seemed happy to consent to his terms.

Within a week or two, the rhino and the goat—aptly, if somewhat unimaginatively, named Goat—were inseparable. The gruff billy patiently indulged Clover when she wanted to play "chase," marked by the rhino's excited squeals and satisfied grunts. When Clover was napping, Goat would deftly clamber onto her back and use her as a lookout point to scout the area. Clover, meanwhile, generously shared her shelter, food, and toys, and was totally devoted to her new companion. She followed him relentlessly—his 1,200-pound lapdog. Despite Goat's occasional irritation at her persistence, Lorinda says the two cuddled up together at bedtime. Reserve staff worried that Goat might be flattened under his weighty sleeping partner, but no such accidents happened. And it was Goat's presence day and night, they are certain, that brought about a complete turnaround in Clover's health. She fattened up and her mood brightened. With a companion nearby, all was well.

BILLY GOAT

KINGDOM: Animalia
PHYLUM: Chordata
CLASS: Mammalia
ORDER: Artiodactyla
FAMILY: Bovidae
GENUS: Capra
SPECIES: C. aegagrus

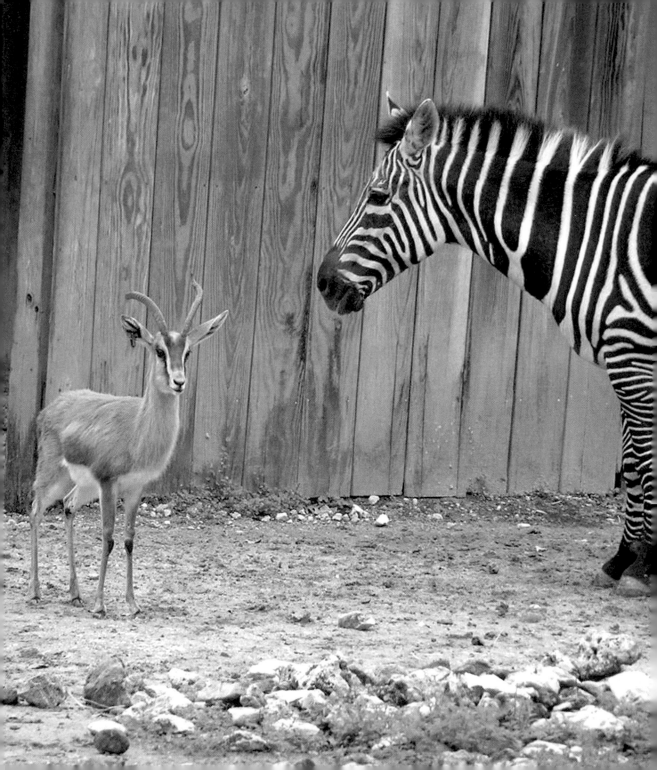

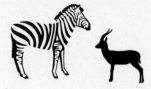

The Zebra
and the Gazelle

HERE'S A QUICK TALE ABOUT A GAZELLE THAT FOUND an unlikely protector in a striped horse.

First, picture a young gazelle in the wild. It's a fragile and vulnerable thing that browses the open grasslands, steppe, and mountain deserts of Africa, Arabia, and India. The petite ungulate's best defense against aggressive types—usually predatory cats—is to run for its life . . . and to be just a bit swifter than the gazelle running beside it.

The Houston Zoo's gazelle will never need to flee an enemy of any kind, it appears.

According to curator Daryl Hoffman, the zoo has a large multispecies exhibit with warthog, zebra, giant eland, nyala (a

ZEBRA

KINGDOM: Animalia
PHYLUM: Chordata
CLASS: Mammalia
ORDER: Perissodactyla
FAMILY: Equidae
GENUS: *Equus*
SPECIES: *E. zebra*

South African antelope), and a lone male Dorcas gazelle—the littlest variety. "When we put these animals together a few years ago, we were concerned for the safety of the gazelle," he says. "Zebra are known to be aggressive toward young or small antelope, and have been known to kill newborns." So they kept a close eye on the situation. (In the wild, a gazelle, fearful of a potential aggressor, might be seen "pronking" away on all fours, as if on pogo sticks.)

To everyone's surprise and delight, one of the female zebras in the mixed-up herd formed a strong relationship with the gazelle. She began to hang out with him all the time, watching over him when he rested, following him around as he wandered, and nudging the smaller mammal to join her when she was ready to move from one spot to another in their enclosure—as a mother zebra might do to her foal.

In a wilder setting, of course, these two hooved animals would have to part ways. Dorcas gazelles typically migrate fairly locally, being well adapted to their arid home and sometimes even surviving without a major water source—getting their liquid from the plants they eat. But zebras' hunger, thirst, and desire to mate send them traveling great distances as the seasons change, joining epic migrations of wildebeest and

DORCAS GAZELLE

KINGDOM: Animalia
PHYLUM: Chordata
CLASS: Mammalia
ORDER: Artiodactyla
FAMILY: Bovidae
GENUS: *Gazella*
SPECIES: *G. dorcas*

other nomadic herds in search of greener, wetter lands. But in the safe haven of a zoo, thosc natural instincts are sometimes supplanted by other instincts. In the case of the zebra and the gazelle, it would seem maternal instincts simply won out.

When the zoo staff introduced a new warthog to the group, for instance, the zebra became extremely protective of the gazelle, as if knowing the big pig could be temperamental. "Whenever the warthog approached, she would step between them, making sure the hog couldn't get too close," says Hoffman.

Especially notable was an incident when the gazelle injured himself and the zebra stepped up her guard. As the staff came in to treat the injured animal, the zebra became frantic and pushed against him, trying to persuade him to get up and out of human reach. "When he wouldn't budge, the zebra tried to block us from approaching," Hoffman recalls. The gazelle was eventually removed and treated in the zoo's clinic. On his return to the exhibit, Hoffman says, the animals were at first tentative around each other. But after a few days, zebra and gazelle had a reunion, ungulate style. They're now clopping through life side by side once again.

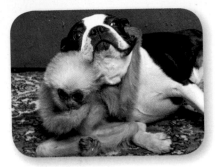

Afterword

ISN'T IT SO TEMPTING, SO HUMAN, TO LOOK INTO YOUR dog's eyes and see love, or to believe upturned lips on any animal's face mean happiness? Consider the dolphin, with that most infamous, enduring smile. It's almost disappointing to learn that the expression has to do with the animal's feeding strategy, not its mood. As author Eugene Linden points out in *The Parrot's Lament*, "If dolphins had evolved to attack their prey fish from above instead of below, they might have been cursed with a permanent frown."

Still, as this book has hopefully convinced a few skeptics, emotion and empathy, pleasure and disappointment aren't only in the human domain. The task of collecting these stories opened my eyes to just how often animals can surprise us with their depth of caring. As word got around that I was gathering interspecies stories, the photos and narratives flowed in daily—many more than I could use. I was introduced to a special place in England called

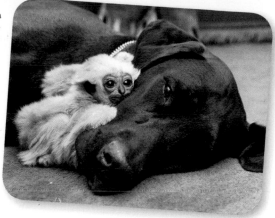

Twycross Zoo with a decades-long history of primates befriending dogs, and to households of mixed pets that played and ate and slept in tandem like human brothers and sisters. I was told about a pup that cuddled with an orphaned porcupine, and I read of a chimp that found a bird in his cage and gently set it free. I considered images of a chick riding atop a turtle, an orangutan walking a dog on a leash, and a mouse balancing beside a lovebird on its perch. I had to cut myself off lest I fill hundreds more pages with funny, sweet, and inspiring tales.

Still, there is one more story that I just cannot leave behind, my own story, so I'd like to close with it here. It depicts an odd combination of fish that I witnessed together on the Great Barrier Reef in Australia in 2009. It doesn't quite fit the "friendship" bill, perhaps, but it's a wonderful account of an interspecies interaction just the same.

Of course, countless types of fish bump fins in the coral reef environment, but this species pairing not only made me laugh (not easy with a scuba regulator in your mouth), but it made me wonder just what might be going on in those little fish brains. The scene was ripe for anthropomorphizing. Please, allow me.

The Author, *the* Sweetlips, *and the* Puffer Fish

ON AUSTRALIA'S GREAT BARRIER REEF, IF YOU DIVE down with the sun's rays as they slice into the sea, a festival of life explodes into view.

At least 2,000 species of fish, plus invertebrates and other critters, wriggle and flit along the walls of the reef, which is a series of coral mountains that rise and fall for some 1,400 miles—the largest living natural structure on Earth. There, on one particularly lively stretch of rock, I witnessed a marine partnership unlike anything I'd seen before.

The ocean is a good place to find "symbiotic" relationships—associations of different species that may offer benefits like access to food, protection, or just a ride from here to there. Think

of clownfish that gain security from predators by living within toxic anemones, or the remora fish that clings to a shark's belly to feed on the parasites living there.

But this was not a case of symbiosis I'd heard about before, nor one that had an obvious explanation. It was truly a bizarre assemblage of "friends." Our dive group—on assignment for *National Geographic* magazine, and including photographers David Doubilet and Jennifer Hayes—had been exploring this site for days, and we'd all seen the puffer fish before. He (I'm guessing the animal's sex) was an old specimen, a tattered softball of a fish. He was always alone, lolling about on the sea floor or moving slowly through the shallows. Oddly tame, he let me approach to within inches and swim alongside him. The manic vibrations of his tiny fins propelled the bulbous fish forward, one eye twitching quick looks my way.

One afternoon as I came off the edge of the reef, I saw my friend the puffer—but this time he wasn't alone. He had found his way to the very middle of a shoal of fish utterly unlike himself. They were sweetlips, a colorful, wide-mouthed type of grunt that schools in large numbers in sunny, shallow waters. The aged puffer, a scruffy blight on their collective loveliness,

was hanging out among them as if he belonged, and the sweetlips seemed oblivious to the invader. The fish hung in the water as if attached to the strings of a mobile, rising and falling in sync at the whim of the currents. The puffer looked absurd yet strangely regal in his place at center, a halo of yellow beauties surrounding his bloated, kingly form.

It wasn't a fluke. The odd cluster was there again later, and the next day as well. The interspecies group was the welcoming party as we arrived on the reef and the well-wishers as we departed. It was a delightful scene.

What interest this giant puffer fish had in the sweetlips, I can only guess. My best "biologically correct" explanation: Both species love a good cleaning, and cleaner wrasses—small fish that pick old skin and parasites off larger fish—are commonly found where sweetlips gather; they're invited to enter the fishes' wide-open mouths to nibble at the leftovers there. Perhaps the puffer realized that to get access to the best cleaning station, he would have to join the crowd. And once he'd found his way to center stage and was accepted there, he simply stuck around.

But there's a more fun explanation, one that would no doubt make any scientist balk. Let's say that by surrounding himself with all that color and beauty, the old puffer gave his sour mood a boost, buoying his lonesome self to that happy place where the best friendships are made.

References

PUBLICATIONS AND FILMS

"Assignment America," *CBS Evening News*, January 2, 2009.

Badham, M. and N. Evans. *Molly's Zoo*. Simon & Schuster, 2000.

Bekoff, M. *The Emotional Lives of Animals*. New World Library, 2007.

Bolhuis, J. J. "Selfless memes." *Science* 20, Nov. 2009, p. 1063.

California Fire Data: http://bof.fire.ca.gov/incidents/incidents_stats.

De Waal, F. *Good Natured*. Harvard University Press, 1996.

Douglas-Hamilton, D., producer. Heart of a Lioness. *Mutual of Omaha's Wild Kingdom*, 2005.

Feuerstein, N. and J. Terkel. "Interrelationships of dogs (*Canis familiaris*) and cats (*Felis catus L.*) living under the same roof." *Applied Animal Behavior Science* 10 (2007).

Goodall, J. Interview with Doug Chadwick for *National Geographic*, 2009, and personal communication, June 2010.

Hatkoff, I., C. Hatkoff, and P. Kahumbu. *Owen & Mzee: The Language of Friendship*. Scholastic Press, 2007, and personal communication.

Kendrick, K., A. P. da Costa, A. E. Leigh, et al. November 2001. "Sheep Don't Forget a Face." *Nature,* 414:165.

Kerby, J. *The Pink Puppy: A True Story of a Mother's Love*. Wasteland Press, 2008, and personal communication.

King, B. *Being with Animals*. Doubleday, 2010, and personal communication.

Laron, K. and M. Nethery, *Two Bobbies: A True Story of Hurricane Katrina, Friendship, and Survival*. Walker & Co., 2008.

Linden, E. *The Parrot's Lament*. Plume, 1999.

Maxwell, L. "Weasel Your Way into My Heart." The Humane Society of the United States (website), 2010, and personal communication.

Morell, V. and J. Holland. "Animal Minds." *National Geographic,* 213:3, 2008.

Nicklen, P. *Polar Obsession* (National Geographic Society, 2009) and personal communication.

Patterson, F. *Koko's Kitten.* The Gorilla Foundation, 1985.

There's a Rhino in My House (film). Animal Planet, 2009.

Vessels, J. "Koko's Kitten." *National Geographic,* 167:1, 1985.

SELECT WEB SOURCES

Animal Liberation Front (animalliberationfront.com)
Best Friends Animal Society (bestfriends.org)
Cute Overload (cuteoverload.com)
Interspecies Friends (interspeciesfriends.blogspot.com)
Mail Online (dailymail.co.uk)
Rat Behavior and Biology (ratbehavior.org)

SELECT ADDITIONAL READING ON ANIMAL EMOTIONS AND BEHAVIOR

Balcombe, J. *Second Nature.* Palgrave Macmillan, 2010.
Bekoff, M. *Wild Justice: The Moral Lives of Animals.* University of Chicago Press, 2010.
De Waal, F. *The Age of Empathy.* Harmony Books, 2009.
Goodall, J. and R. Wrangham. *In the Shadow of Man.* Harper Collins, 1971, and Mariner Books, 2010.
Hatkoff, A. *The Inner World of Farm Animals.* Stewart, Tabori & Chang, 2009.
Hauser, M. D. *Wild Minds.* Henry Holt and Co., 2000.
Masson, J. M. and S. McCarthy. *When Elephants Weep.* Delacorte Press, 1995.
Page, G. *Inside the Animal Mind.* Doubleday, 1999

Acknowledgments

This project was very much a collaborative effort, as there would be no stories were it not for the storytellers. They were pet owners, zookeepers, animal rescuers, photographers, biologists, and other animal lovers who witnessed interspecies interactions, realized the moments were special, and were willing to share what they saw. My deepest thanks to the kind people, many of them quoted in these texts, who patiently provided information and images to make the collection possible.

I am also extremely grateful to the staff at Workman Publishing, especially Raquel Jaramillo for seeking me out to do this project and kindly praising the result, Beth Levy for shepherding the manuscript through copyediting and proofreading, and Melissa Lucier for her tireless efforts tracking down photographs all around the world.

Finally, I thank my family, friends, and colleagues who helped along the way. They include but are not limited to:

- Lynne Warren, for kindly editing the first messy draft

- Melanie Costello, for keeping me organized and confident

- Penny Bernstein, for endless ideas and support

- Mari Parker and Chen Yiqing, for translations

- Lorie Holland, for enthusiastic promotion and sales advice

- My husband, John, for tolerating the ups and downs and my obsessive reading aloud

- My niece and nephews for giving me the best reasons of all to tell these tales

- My much-adored mother, for passing on her love of animals to me.